How To
Photograph
Selling Nature
Photographs

How To Photograph

Selling Nature Photographs

Norbert Wu

STACKPOLE
BOOKS

Published by
STACKPOLE BOOKS
5067 Ritter Road
Mechanicsburg, PA 17055

Printed in China

10 9 8 7 6 5 4 3 2 1

First edition

Advertisement and brochure on pages 33 and 35 courtesy of the
British Virgin Island Tourist Board. Cover on page 63 from A Chorus of
Frogs by Joni Phelps Hunt © 1992 Published by Silver Burdett Press,
Simon and Schuster Elementary. Used by permission of the publisher.
Cover on page 64 reprinted courtesy of the American Society of
Media Photographers (ASMP). "Natural Moment" spread on page 71
reprinted with permission from Natural History (2/95) © the American
Museum of Natural History, 1995. Text by Judy Rice. Cover of A City
Under the Sea on page 93 reprinted with the permission Atheneum
Books for Young Readers, an imprint of Simon & Schuster Children's
Publishing Division from A City Under the Sea by Norbert Wu © 1996
Norbert Wu. Cover of Illustrert Vitenskap on page 104 courtesy of
Illustreret Videnskab/Bonniers Specialmagasiner.

Library of Congress Cataloging-in-Publication Data

Wu, Norbert.
 Selling nature photographs/Norbert Wu
 p. cm. – (How to photograph)
 ISBN 0-8117-2459-X (pbk.)
 1. Nature Photography. 2. Photography—Business methods
I. Title II. Series
TR721.W8 1997
778.9'3'068—dc20 96-35313
 CIP

CONTENTS

Acknowledgments vii
Introduction . ix

Part I: The Hard Truths of
Nature Photography **1**
It's Still Worth It . **6**

Part II: Building a Library **7**
Films and Cameras 7
The Physical Library 8

Part III: Slide Duplication **20**
The Craft . 20
Subtractive Colors 24
Larger Dupes . 25

Part IV: Markets for Your Photographs . . **29**
Stock Agencies . 29

Part V: Strategies for Success **42**
Specialization . 42
Obtaining Travel Assignments 46
Composition . 58
Your Stock Library 64
Taking on a Self-Assignment 66

Part VI: Marketing **70**
Knowing Your Market 70
A Typical Submission 72
Be Prepared . 78

Part VII: The Real World **87**
How to Recognize and Help Your
Best Clients . 87
Doing a Book . 91

Part VIII: Pricing and Negotiation **102**
The Value of Copyright 102
Pricing and Negotiation Strategies 108
The Value of Communication 111

Part IX: Better Business Practices **114**
Seeing the Customer's Point of View . . . 114
ASMP's Guidelines 115
Situations and Solutions:
Common Problems in Marketing
Your Photography 116
Patience Is a Virtue 118

Part X: Tricks of the Trade **120**

Part XI: Ethics and Etiquette **123**
Business Ethics . 123
Ethics in Nature Photography 127

Resources . **129**

ACKNOWLEDGMENTS

Howard and Michele Hall welcomed me upon my move to San Diego, introduced me to their film projects and friends, and showed me how to have fun while working, all the while setting an example for me to follow over the years. To them I owe the greatest of thanks. Peter Brueggeman, friend and knight of the information age, has helped me with many tasks. Kris Ingram has managed my office during these hectic years with good cheer and professionalism. Dan Walsh has been a source of support and information throughout the years. Scott Highton, Emily Vickers, Dick Weisgrau, and other folks associated with ASMP have provided invaluable advice and information over the years.

Cindi Laraia at Dive Discovery and Bob Goddess at Tropical Adventures are among the finest travel agents in the world, and they have helped me get to many a location. Doris Welsh of Galápagos Network and Noel D'Souza of Wildlife Safari helped me with my travels in the Galápagos Islands and Kenya. Geoffrey Semorile and Sam May at Camera Tech in San Francisco have serviced my cameras and offered invaluable assistance and advice over the years. I have discovered a true gentleman and genuinely interested manufacturer in Ike Brigham, owner of Ikelite Underwater Systems. Stuart Cove's Dive South Ocean in Nassau and Walker's Cay in the Bahamas helped me obtain some fabulous shark photographs.

The participating photographers in my small stock agency, Mo Yung Productions (Mo Yung means "useless" in Chinese!), deserve many thanks. They have placed their confidence and their greatest treasures in my library, and they have helped make Mo Yung Productions one of the finest collections of marine life photographs in the world. Thanks to Brandon Cole, Mark Conlin, Bob and Cathy Cranston, Ben Cropp, Mark Edwards, Peter Howorth, Peter Parks, and James Watt.

My family has been endlessly supportive. My thanks and love go to my parents and Deanna, and my hopes and love go to Alberta and Lance.

INTRODUCTION

People who know how successful I have been in my career as a nature and wildlife photographer often ask me what my secret is. Many of them also think that I must lead a glamorous life of travel and excitement. The reality is that most of my working life is sheer drudgery. My secret, if you can call it that, is simply hard work and a keen interest in everything related to photography, nature, and my business. I spend most of my time cooped up in my office, doing paperwork involved with my photography business as well as mountains of paperwork that the government requires of small-business people. I do travel a great deal, but if I subtract the interminable hours of sitting on planes and waiting in line to get through customs, I am left with only a few days a year of actually working in the field. I work very hard, and it can be hard, frustrating work, not the glamorous life idealized in Hollywood movies. I just happen to love my work, and that has made all the difference in the world. Thomas Edison's statement that invention is 99 percent perspiration and 1 percent inspiration applies to photography as much as any other career. By working hard, I have created a huge library of wildlife images. My keen interest in nature and photography has allowed me to immerse myself in my chosen work, to read as much as I can find about these subjects, and to apply what I read to my work. It's a heady combination, but I would not be truthful if I said that my life was glamorous.

There is no secret to marketing nature and wildlife photography. There are, however, many commonsense practices involved, and some reference books and newsletters can be of great help. In this book, I discuss specific ways to market your work through the avenues of cards, posters, calendars, and books and give straight, honest answers to the questions that many photographers in my seminars ask. I describe exactly how I work, what tools I use, what films I prefer, and how I send out submissions and present my honest opinions about relevant topics, books, equipment, and other resources. This book, rather than saying only nice, general things about photography and equipment, gives specific information, including both complaints and compliments about products, manufacturers, and their services. (Camera manufacturers don't like a critical approach to their gear, so send any contributions in care of the author, as I will be losing all those lucrative endorsements from the manufacturers.) I also reveal some tricks of the trade that are not described in other books, that I have compiled only through years of experimentation and association with other professionals.

Throughout this book, I refer to such basic photographic ideas as shutter speed, aperture, depth of field, and film size. Terms and comparisons refer to 35mm cameras and lenses; however, the basic principles of lighting, composition, and business remain the same whether you are shooting a medium-format Hasselblad or a 4×5-inch view camera.

This is an exciting time to be a nature photographer. New and easier-to-use equipment is constantly being introduced, and the new electronic autofocus cameras are making photography almost foolproof. New methods of distributing and featuring photography are popping up, and the pace of these technologies is breathtaking. Because of the tremendous pace of digital technology, I do not describe any of the technologies in detail. For more information on current technology, consult industry periodicals such as *Photo District News*. Nor do I include any lists or tables of recommended prices. Such tables can be found in books such as Jim Pickerell's *Negotiating Stock Photo Prices*. Basic business practices will always hold true, however, and it is these basic philosophies that I hope you will glean and hold from this book.

Cheetah chasing Thomson gazelle fawn, Kenya. *One of my major stock agencies, perhaps the second-largest agency in the world, needed shots of cheetahs running and sharks attacking when I first started with them. As a specialist, it was easy for me to get shots of sharks. It was much harder for me to obtain photographs of cheetahs, and I admit that this is not a great shot. I haven't had the time or resources to get a great shot of a cheetah running yet, but one of these days I will.*

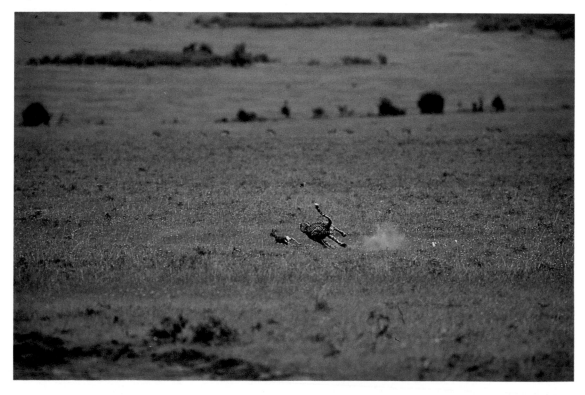

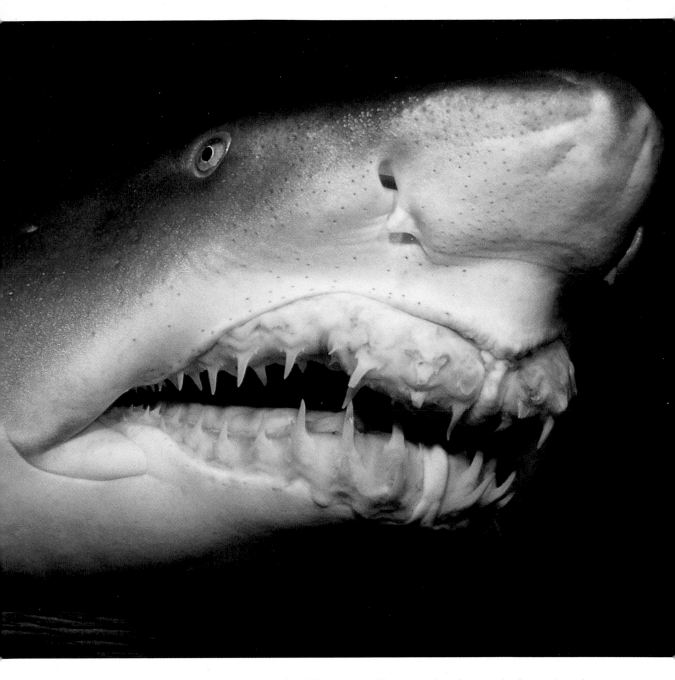

Sand tiger shark, Steinhart Aquarium, San Francisco. *Photographs of animals that epitomize or evoke an emotion are always big sellers, both for the editorial market and for the generic stock market. Any photograph that can symbolize a human trait, or make the viewer feel an emotion, will do well in the marketplace.*

Jim Pickerell, author of *Taking Stock Newsletter*, conducted an interesting survey in September 1994. He polled the subscribers to his newsletter *Taking Stock*, the *Guilfoyle Report* (which caters to nature photographers), and *Photo Stock Notes*. He discovered that the average gross earnings for photographers (not just nature photographers) were about $69,000. The highest gross income was $500,000. Subscribers to the *Guilfoyle Report* averaged a lowly $38,000 annually, with a median income of $24,500. It's obvious from these figures that many nature photographers need help in their businesses. When Jim eliminated most of the part-timers and those just getting started in nature and wildlife photography, he found that the gross income rose to nearly $65,000, a much more respectable figure.

As a nature and wildlife photographer, you have one huge advantage over commercial advertising and other photographers. Photographs of nature and wildlife are undated, timeless. A good photograph of a cheetah running or a shark attacking can sell year after year in an agency's files. This makes your potential income stream long term, but it also means that competition is fierce. You are competing not only with your contemporaries but also with photographs taken ten years ago. In contrast, photographers of people and fashion must constantly work to update their files. Hairstyle or clothing changes make their work obsolete quickly. I have seen my income from my photography rise exponentially over the ten years that I have dedicated myself to my career. There is no reason why your nature and wildlife photographs cannot do the same for you.

The best wildlife and nature photographers are good, careful naturalists who are completely at ease with their gear and themselves in the natural environment. Knowing the habits and behaviors of wildlife contributes to making unique, salable photographs. Getting to know what you will encounter and tailoring your equipment to a particular subject will give you the best results.

The Hard Truths of Nature Photography

Many people think that life as a professional photographer is a romantic one, and they dream of pursuing that existence themselves. In reality, however, life as a photographer means a lifetime of failures, rejections, uncertainty, and isolation. You never hear about these failures, but it is simply because photographers never talk about them, and because stories about photographers' failures, other than the humorous ones involving charging rhinos and broken cameras, do not sell. What book is going to describe its author in something other than glowing terms? What magazine will bring up the past failures of a photographer featured in the issue's portfolio? More likely, any photographer featured in a magazine or books is touted as one of the best photographers around, one of the most adventurous, one of the most talented, or one of the rising young stars. Consequently, the average reader develops an overly glorified view of the life of a photographer.

I hope that this section will give you a better idea of the realities of life as a nature photographer and thus enable you to make a better decision about choosing a career in nature photography. The following are some myths and truths of the profession.

Myth #1: We lead adventurous lives, make lots of money, and travel for free.

Truth: I spend most of my waking hours at the office. I do travel quite a bit, but rarely for free, and then only with strings attached. I've made a good living the past few years, but I do not know how things will go next year. Much of it depends on how much I work in the office, writing proposals, duplicating submissions, and negotiating sales. The more time I spend in the office, the more money I make, but the less I enjoy myself. When things get too bad, I go out and play with the dogs. Sam, our golden retriever, can now catch an Aerobie thrown 6 feet high, nearly 100 yards away. Ange, our clumsy but good-hearted yellow Labrador, still can't do much of anything.

My travel is often the result of speaking engagements, which rarely pay more than expenses and rarely take me to more romantic destinations than Washington, D.C. Just about all the travel I do for my photography comes out of my own pocket. If I did not speak and write, I would be in much less demand, and I would consequently travel less. For instance, I am preparing to travel to the Seychelles Islands for a film festival there, where I will be speaking. Since I have to be there in about six weeks, I have been scrambling around, faxing madly to destinations in Kenya and Indonesia, trying to get information about places to stay and photograph on my way out to the Seychelles. This is called piggybacking, and I do it whenever

1

part of my trip is paid for so that I can get to other sites at minimal expense.

It would be nice if a magazine would simply call me up and pay all my expenses to photograph a story on wildlife in Africa, but the fact is that almost no magazines do this. In twelve years of working professionally as a wildlife photographer, I have landed only a couple of assignments for magazines, and only two or three commercial assignments. None of these jobs entailed going any farther than my home state of California. I have been published widely, but these have all been sales from my existing library. Only those at the very top of the heap, the very pinnacle of nature photographers, have the reputation and connections to be assigned regularly to nature and wildlife stories. I know of only one magazine in the country that regularly assigns nature stories to photographers, and that magazine, *National Geographic,* is increasingly oriented to topical issues.

Myth #2: We get all sorts of free equipment from the camera companies.

Truth: I have never, ever received a single free piece of gear from a large camera company. Nor has any other photographer that I have talked to. I do hear stories occasionally about a famous photographer receiving free gear in exchange for actively using and promoting the camera brand, but when I later meet these people, I find that this is a myth. Nikon, Canon, and other companies do offer professional photographers membership in what they term "professional services," but these "clubs" offer little more than quick repair services and limited loan of equipment. More often than not, I have found their loaner programs to be unworthy of my time. The lens that you need is often loaned out, too old and banged up to give good results, or only available for a few days, rather than a few weeks. I buy all of my equipment myself after careful research. I do have to commend Canon Professional

Services for their long-term loan of a lens and camera for an Africa trip in November 1994, although that came about only after my editor cleared the loan for an assigned story on the lens and camera.

Seychelles Islands, Indian Ocean. *I first visited these idyllic islands several years ago as the result of a speaking engagement. I created a travel story based around diving, which required many scenic shots, as well as shots including people. The story has since been published in more than a dozen magazines worldwide because of the diving angle.*

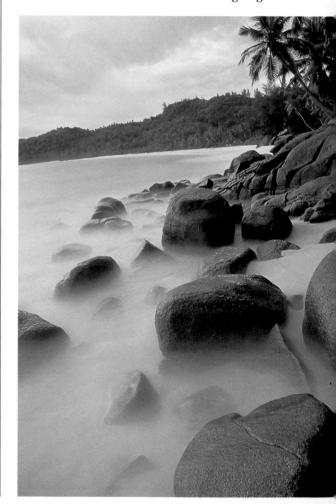

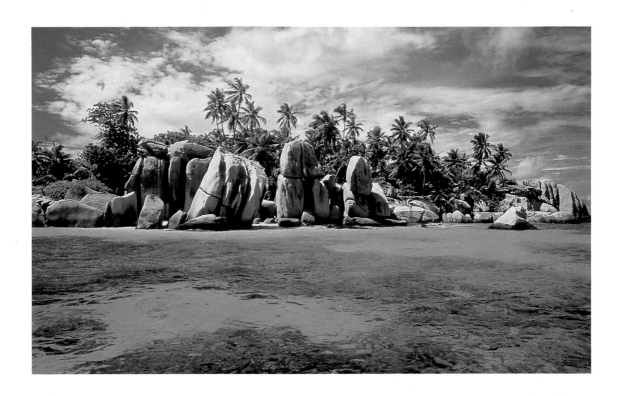

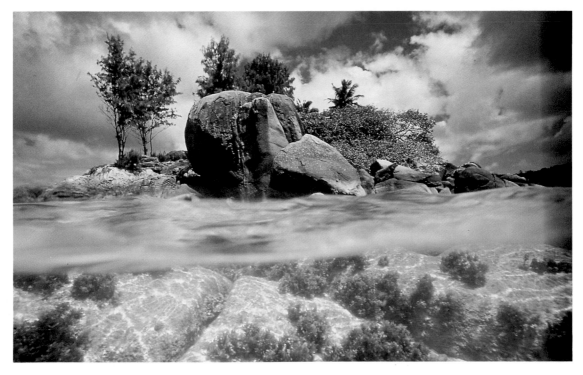

Myth #3: Once you've developed a reputation, photography buyers come knocking at your door.

Truth: I don't know a single photographer who doesn't work very, very hard at selling himself. One of the things I have learned through the years is that photography buyers don't necessarily remember you, or call you, even if you have worked with them before. They need constant reminders of your work. The other fact of life in this business is that constant rejection of your proposals and photographs occurs daily. I have learned to take rejections, but it still hurts when a project that I believe in, and that will undoubtedly be successful, is continually rejected. Robert Pirsig, author of the tremendously successful book *Zen and the Art of Motorcycle Maintenance,* has often stated that his manuscript was rejected by 120 publishers before finally finding one!

Myth #4: Stock agencies are a great way to make money.

Truth: Be very careful in signing with any stock agency. Never sign an exclusive contract, and don't believe anything that an agency promises you. Never hand over your best work.

I believe that stock agencies are the most overhyped myth of the industry. Not one of my agencies has grossed more than 5 percent of the sales that I bring in myself, working out of my small office. The main problem is that most nature photographers are spe-

A male garibaldi removing a sea urchin from his algal nest, California. *I took this photograph on one of the first assignments of my career, for* National Geographic Books. *Ironically, the assignment was to photograph California's Channel Islands, which is where I had gotten started with diving and photography. My most recent assignment, for* American Way *magazine, took me back to these same islands to photograph blue water hunters.*

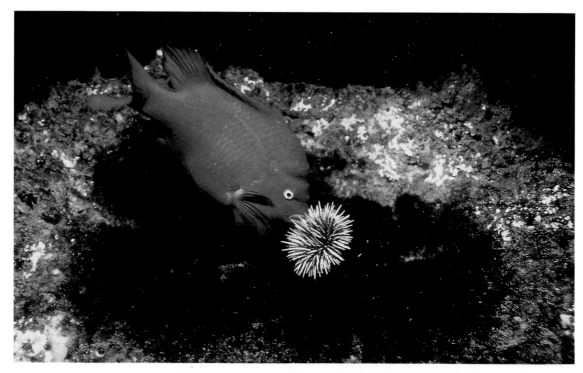

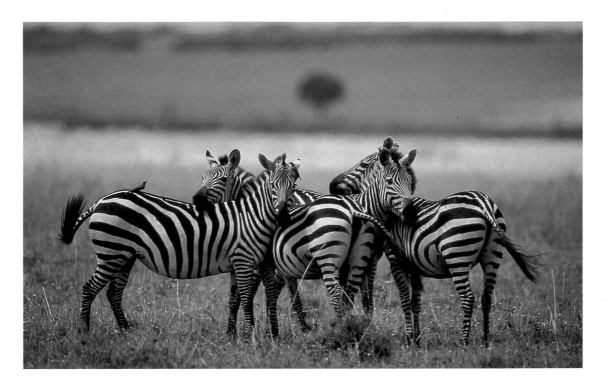

Oxpeckers on Burchell's zebra, Kenya.
Many thanks to Canon Professional Services, which came through with a 600mm lens and EOS-1 body for an entire month in Kenya.

cialists—in behavior, a particular type of animal, or a type of photography. The typical stock agency makes very few sales of nature photography as compared with their corporate and advertising images of people. The photo researchers in stock agencies simply don't have the knowledge of subject matter or the time to do a quality-oriented, scientifically accurate job.

I believe that the increasing presence of stock agencies in the editorial market is adversely affecting the business of the nature photographer. They are taking bread-and-butter business away from photographers by selling photographs at cut-rate prices, in large bulk deals. Individual photographers are left handling the hard-to-get requests from publishers who expect usage fees to match those of the cut-rate stock agencies. I have been appalled at how low my photographs have sold from one agency in particular. It was this agency that promised the world to me initially and

required a monumental investment of time to caption each image its way. This agency asked me to submit my very best images, and it wanted exclusive rights to represent my work. Fortunately, I was very careful, holding on to my best images and agreeing only to a nonexclusive contract. I did, however, spend hundreds of hours captioning my slides its way and filling its requests, even going to the extent of shooting stock for its want lists. After two years, this agency has performed worse than any of my others. It required more time than any other activity last year, but only did about 1 percent of my gross. In short, this agency promised great things, asked for a great deal of time and material, yet has never deliv-

ered. I would be out of business now if I had believed this agency's promises, given in to their requests for exclusivity, and let my best photographs out of my office.

Myth #5: It must be great to be your own boss.

Truth: Life as a photographer is busier and more stressful than any corporate job could be. As a freelance photographer, you are isolated and inundated with small, time-consuming tasks like captioning, sending off submissions, and maintaining a photo library. The isolation can be numbing; it takes a very strong sense of will and purpose to keep working alone, both in the field and in the office. Photographers are

Diver swimming among lemon butterfly fish, Hawaii. *This is a best-selling shot at one of my large agencies. Most stock agencies are oriented to selling photographs to the commercial and advertising markets. As such, photographs of people in nature will sell far better than the typical nature photograph that does not include a person.*

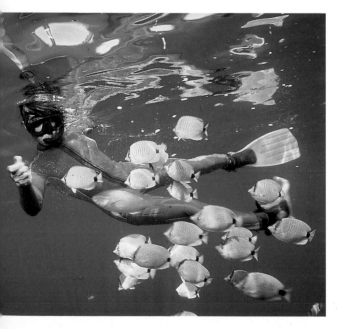

always the bottom ones on the totem pole. Ann Guilfoyle, in a recent *Guilfoyle Report,* discussed how the electronics age is isolating nature photographers even further from their clients with impersonal answering systems, faxes, and computers. We work in isolation, with very little status or power, and with no job security whatsoever. We have no important-sounding titles, and no status or connection with any institution, be it scientific or artistic.

Nature photographers have no source of funding at the national level whatsoever, as nature photography is considered neither art nor science. The federal grants of the National Endowment for the Arts (NEA) and the Humanities (NEH), the Guggenheim Fellowships, and numerous other grants in the arts and sciences don't consider nature photography to fall within their guidelines. It is astounding to me to see some of the "art photography" that is being funded by these programs, and I am always appalled at the obsession people have with photographs of the human race, rather than the millions of other beings that share this planet.

It's Still Worth It

Nevertheless, there is nothing like working for yourself, seeing your work in print, and seeing new photographs on your light table. Nature photography is not accepted as an art form by the establishment now, but I am certain that it will be considered an important view of the world down the line, probably the only significant art to come out of our generation. With hard work and a good eye, it is possible to make a good living at this profession. A good friend of mine recently sent me a cartoon with the caption "The Advantages of Being Self-Employed." The picture showed a man sitting at his desk with a big grin on his face, and twelve framed photographs of himself behind his desk. Each photograph was labeled "Employee of the Month."

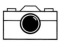

PART · TWO

Building a Library

Films and Cameras

As a nature photographer, you are confronted with choices. Probably the first and most important choice is the film format, which dictates the type of camera you will use.

For most people, the obvious choice is the 35mm format. The 35mm format has been the standard for wildlife shooters for the past twenty years. The films available for 35mm keep getting better and better. Examples of great 35mm film with terrific color saturation, ultra-fine grain, and superb sharpness are Kodak's Ektachrome 100S and Lumiere and Fujichrome's Velvia and Provia. The range of lenses, camera bodies, and accessories for the 35mm format is unsurpassed. For the average nature and wildlife shooter, for the beginner, and for most seasoned professionals, 35mm is the best format choice. Manufacturers of 35mm equipment include Canon, Minolta, Nikon, Pentax, and several others. The majority of professional wildlife photographers shoot Canon or Nikon.

You can get 35mm film in negative film and positive, or transparency, film. Color negative films are usually named with a suffix of *color,* such as Fujicolor, Kodacolor, and Ektacolor. Color transparency films, also called slides or chromes, have names that end with *chrome,* such as Ektachrome, Fujichrome, and Kodachrome.

To see the results of negative film, it is necessary to print the film onto paper. The processed film has an orange cast and a negative image. Color transparency film, on the other hand, shows the resulting image immediately. The slide is viewed by using a slide projector or by placing it on a light table. Because transparency film is viewed directly, it has become the preferred type of film for photographers and for publishers. Although color negative film has several advantages over transparency film, such as lower contrast and greater tolerance for exposure errors, nearly all professional photographers use transparency film. Nearly all stock agencies and magazine publishers prefer to see chromes rather than prints, and showing them transparencies is a mark of professionalism.

Other film formats do have their role. If you plan to specialize in shooting landscapes, you will probably be better off using a 4×5 or larger format camera. If you plan to make your living shooting weddings, then using a Hasselblad or Mamiya in the 6×6cm or 6×7cm format is best. If you'd like to get an edge over the rest of the crowd, shooting wildlife with medium-format cameras or panoramic cameras may give you that edge.

I shoot 35mm almost exclusively. Nearly everything I say in these pages refers to Canon or Nikon equipment, which are the

two brands of cameras that I use for 99 percent of my shooting. I use different films depending on where I am shooting. For instance, if I am shooting wide-angle scenes underwater, I like the contrast and feel of Kodachrome 64. For general topside shooting, I like the colors and tonal latitude of Fujichrome Sensia film. For close-up subjects where I want great color saturation, I will use a highly saturated, fine-grain film such as Fujichrome Velvia. For topside scenics that need extra sharpness or color saturation, I will use an ultra-sharp, fine-grain film such as Kodak Lumiere or the new Ektachrome 100S. If I were to recommend one general film for nature and wildlife photographers, it would be Fujichrome Sensia. This film can be purchased through B and H Photo in New York at extraordinarily low prices (around $3.99 per thirty-six exposure roll), and it is a fine all-around film.

The Physical Library

Most nature photographers have to overcome the expectations of their peers, parents, and colleagues to pursue their goal of photography. Most people advised me to continue my career in engineering while working on my photography in my spare time. I disagree. To produce top-quality wildlife essays or stock photographs, you have to dedicate yourself to shooting a project or studying the stock photography market. I could not possibly divide my time between the restrictions of a corporate job and moonlighting in photography on the side. To make it in this tremendously competitive marketplace, it is first necessary to believe in yourself and your work, and that you can make a decent living doing what you truly love to do. Most aspiring photographers fail in grasping that photography as a business means a continuous, unending stream of office work. This necessarily precludes another full- or even part-time job. Selling photographs is a time-consuming, mind-numbing, and tedious task at best. Over the years, I've developed a set of routines in running my business. I've examined other photographers' and agencies' office practices as well. In the following sections, I'll explain how I organize my work, find and keep track of my clients, and use my computer.

The medium-format size of the Hasselblad camera is a definite advantage over the much smaller 35mm format, when compared side by side. The compactness and greater versatility of 35mm equipment negate many of the Hasselblad's advantages, however. If your goal is to get the highest-quality reproductions at large print sizes, a medium-format camera is the way to go.

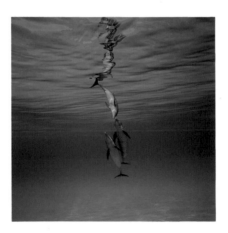
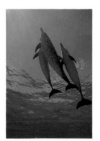

Photograph of dolphins and swimmers shot in Hasselblad format, printed at original size. Similar photograph of dolphins shot in 35mm format, printed at original size.

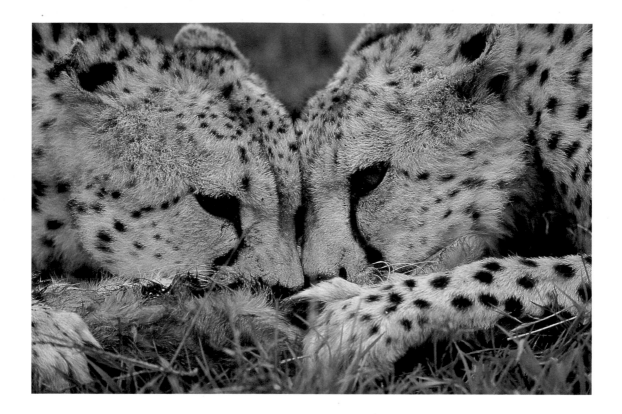

Examples of photographs shot on different types of film (pages 10–14), each of which has different characteristics.

Hunting pair of cheetahs feeding on a Thomson gazelle fawn, Kenya. Fujichrome Sensia film. *This film has been around for a long time, and it has long been my favorite for daylight shooting. I like it for its low contrast and good color saturation. Its only drawback is a medium-sized grain, which is noticeable only in large reproductions, such as a full page.*

Office Equipment

A computer with a good word-processing program, a database, and a mail-merge function that allows custom form letters is an absolute necessity for your business. My mailing list is one of the most important parts of my business, and I update and refer to it each day. Each time I go to a bookstore, camera shop, or card store, I get the addresses of the publishers of the greeting cards, magazines, books, and calendars that are on the shelves. I get addresses of potential clients everywhere. Lists of newspapers, magazines, and paper products companies abound in libraries. All of these addresses go into my computer, into a client file.

I rarely visit clients; instead, I periodically send all the clients on my list an update of new photographic subjects and story possibilities. Every bit of information, every idea, every phone number, every name and title that I hear or read about goes into my database. In this way I know exactly who it is I

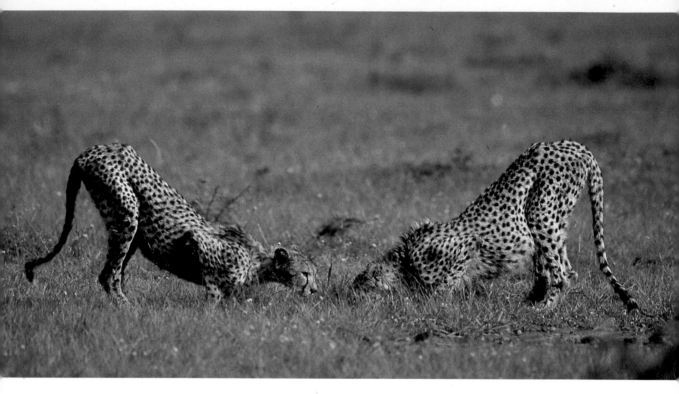

Hunting pair of cheetahs drinking from water hole, Kenya. Fujichrome Provia film pushed one stop. *This newer film has similar characteristics to Sensia film, but it has a tighter grain and better archivability. I use it for scenes that demand fine grain and good latitude. I pushed the film one stop, for an effective ISO of 200, for this shot. Both Sensia and Provia push well; the colors remain saturated and the grain increases only slightly.*

am speaking to on the phone, and I have an instant reference of our conversations. No information is lost, and I follow up on every lead as if it were my first contact. I subscribe to over a dozen journals and magazines about the photographic, writing, and diving industries. During my reading, each bit of potentially useful information goes into my database, under the headings of manufacturers of photographic equipment, manufacturers of diving equipment, magazines, books, children's books, museums, advertising agencies, and so on.

I have long been an Apple Macintosh user, but any good computer system will work fine for a small business. I use my computer for standard business correspondence, invoicing, and recordkeeping. I do *not* use my computer for digital image manipulation. I decided several years ago that I would not use computers for image manipulation for a very practical reason: I did not have enough time. I spend enough time in front of my computer doing taxes, insurance, and other tasks that are demanded by the government. I prefer to spend what time I have left in the field, taking photographs of wildlife and nature. The last thing I wish to do is spend more of my waking hours in front of a computer, manip-

ulating images. Other photographers, obviously, feel differently. Several photographers have done quite well at using computers to create images that could not otherwise be done in the field. It's really all a matter of what you wish to spend your time on. I am a firm believer that you can make money doing anything that you care to spend your time on, as long as you do it well. I care to spend my time in the field and to market my photographs, not manipulate them. Advertising and design agencies routinely use computer manipulation these days to create photographs that better fit their needs. While I do not manipulate my photographs myself, my images are commonly digitally manipulated when used in ads.

I am a big fan of Microsoft Word for the Macintosh. Using this program, I can easily and quickly compose letters to clients, using the addresses in my database and other letters, articles, and files on my hard drive. Word also allows me to print customized form letters to different classes of clients. Word's powerful and unique column-processing capabilities allow me to sort documents according to zip codes, company names, addresses, or any column of information. I also use Word's mail-merge capabilities to print captions for my slides on 3$1/2$-by-$7/16$-inch self-adhesive labels. It is

Chameleon in highland forest, Kenya. Fujichrome Velvia film. *Velvia film has ultra-fine grain, incredible color saturation, and high contrast. I use it for shooting close-ups, where I can control the contrast on the subject by using my flash.*

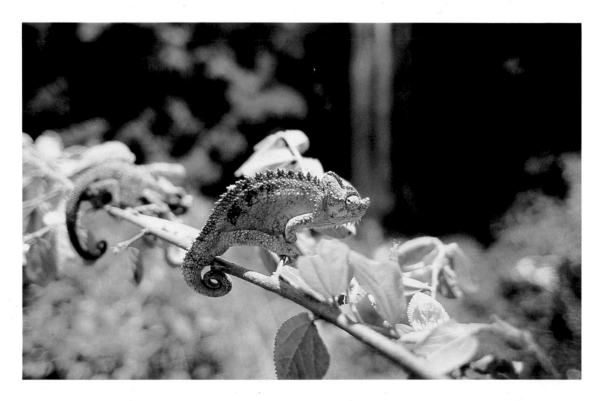

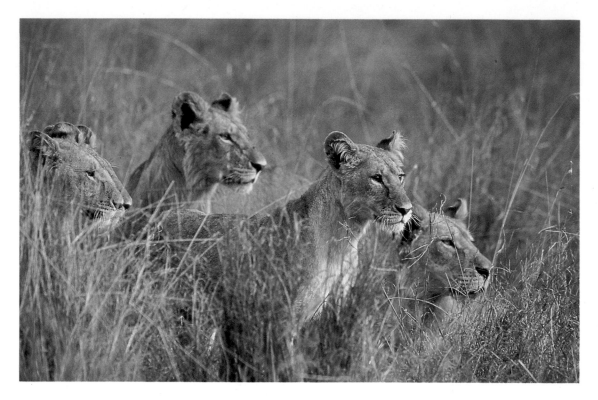

Pride of lions, Kenya. Ektachrome Elite 100 film. *This photograph has been used on the cover of a brochure, and the tight grain enlarged very well. Elite film has fine grain, great color saturation, and high contrast. I've enlarged images on Elite film to 48-inch sizes, with barely noticeable loss of sharpness or grain.*

This shot on the cover of Wildlife Safari brochure. *Courtesy of* Wildlife Safari.

not the most elegant system, but it works for me. Any decent computer system will do the job, and that is what's important. I prefer the Apple Macintosh system because it mimics the way most people are used to working. The computer organizes data into files, and those files can be organized into folders. The system works from a "desktop."

I now have three computers in our small

office, a laser printer, a dot-matrix printer (for printing slide labels and Federal Express forms), and a couple of fax-modems. Everything in the office is networked quickly and easily, simply by hooking up telephone cables and appropriate Phonenet connectors. Simplicity and ease of use have long been hallmarks of the Apple Macintosh system. In fact, I am writing this text now in the Miami Airport (in between shark dives in the Bahamas) on an Apple Macintosh Powerbook. When I return to the office, I will hook my notebook computer up to the network and simply transfer files to my main computer. You can do the same thing with PCs, but I am told that it takes a lot more work to get the systems up and running.

Several software packages written specifically for the photographer for both the Macintosh and PCs are available, and their capabilities vary. I have learned the hard way that these programs can take a great deal of time to use them. After several disastrous and prohibitively time-consuming attempts to apply a few specialized programs to my office duties, I have decided to spend my time and money on only the most general, flexible computer programs. On my Apple Macintosh, I have been able to do almost all of my work on my word-processing program and database. I programmed my database application (Filemaker Pro) to perform my invoice and photo delivery tracking, as well as to maintain my client list. Off-the-shelf software packages for photographers are available and will probably do all that I need and more; however, I chose to learn how to program my database

Blooming iceplants, Pacific Grove, California. Ektachrome E100S film. *This new film has good color saturation, a fine grain, and low contrast. It's a wonderful choice for topside shooting.*

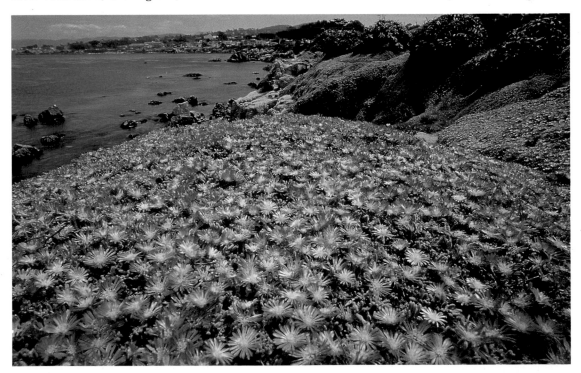

so that I could customize my programs to do exactly what I need them to do.

By learning how to program a general database package instead of purchasing a software package, I have more flexibility and power. I've been able to make my computer do things exactly the way I want. For instance, if I am preparing a shipment of photographs to a client, I will prepare a delivery memo in my database application. This delivery memo record will keep track of the original and duplicate photographs that have been sent out and returned. With the push of a button, my computer will prepare a Federal Express shipping label for the package, the delivery memo itself, a list of terms and conditions for the delivery, and it will keep track of the number of days the photographs have been out. Every month, with the touch of a button, I am able to print out statements to clients requesting the return of late photographs. With new versions of database software, I can foresee the ability to click a button, have the computer dial Federal Express for a pickup, fax the delivery memo to the client, and prepare thumbnail images of the photographs that have been sent out.

My laser printer is another essential investment. It produces professional-looking manuscripts and letters, and it is the only practical way to produce mass mailings to my clients. I can use it to print envelopes, delivery memo forms, contracts, manuscripts, and virtually any form of black-and-white artwork and imagery. My old dot-matrix printer prints out anything that requires carbon copies, such as Federal Express and United Parcel Service (UPS) labels. I also print the captions for my slides using my dot-matrix printer. I buy $3^1/2$-by-$^7/16$-inch self-adhesive labels from the

Baby Burchell's zebra nursing, Kenya. Kodachrome 200 film. *In overcast and low-light conditions on land, Kodachrome 200 is a good choice. It has a fairly large grain but exhibits good sharpness.*

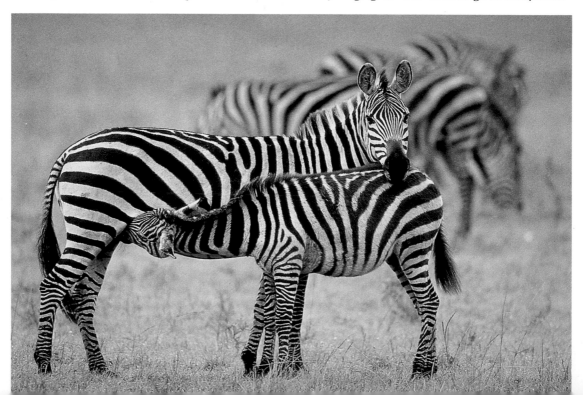

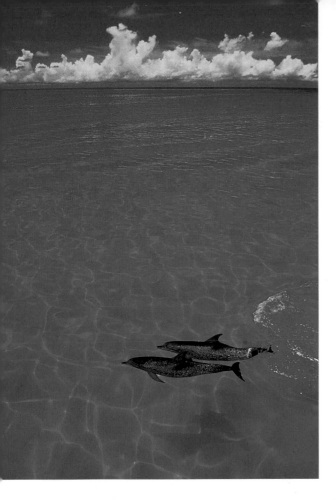

Cover of *Scuba Times* showing dolphin image used vertically, as it was shot. *Reprinted with the permission of* Scuba Times *magazine*

Atlantic spotted dolphins, Bahamas Banks, Caribbean. *This image, which I shot as a vertical, is ideally suited for magazine and book covers, and has been used on several.*

Stock Solution, in boxes of ten thousand for about $40 each. Most of my photo captions are stored on my computer in a text file, and it is an easy matter to cut and paste various captions using the computer to quickly create captions for hundreds or even thousands of slides.

My fax machine has also proven invaluable, particularly for reaching my international clients. E-mail has become a good and inexpensive way for both international and domestic clients, as well as friends, to reach me. I have found, however, that E-mail seems to be less highly regarded than a fax or a let-

ter. Busy clients often ignore the questions that I have posed in E-mail messages, but they will promptly answer a fax and a letter. And if you really need to work something out with a client, a phone call is still the best way. My computer's fax-modem is a combination fax machine and modem in one. I have one of these small electronic marvels in both my main office computer and my small notebook computer. As a subscriber to Compuserve International Service, I am able to receive and send E-mail messages with the touch of a button both from my desktop and while I am traveling. I can access the World Wide Web and its many multimedia marvels using the modem. I can send a fax that incorporates both my signature and my logo with the fax-modem. When I am traveling, I can log into Compuserve from anywhere in the United States, and from many

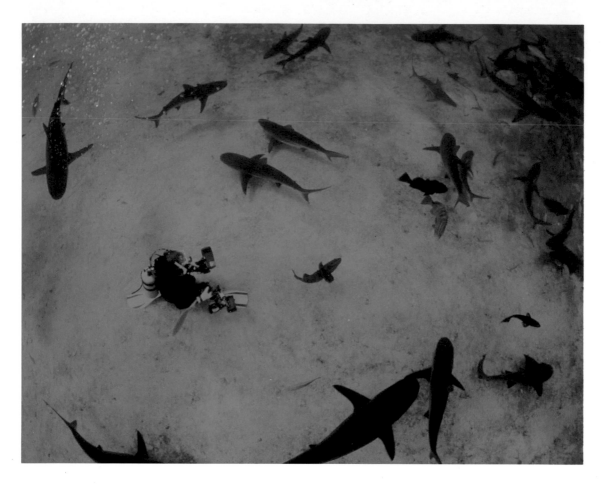

Diver surrounded by sharks, Bahamas.

foreign countries as well, to receive my E-mail messages. In this way, I keep in touch with my office when I am out of town.

A personal copy machine is another necessity. By placing a sheet of transparencies on the copier face down and shining a 200-watt bulb over the sheet, it is possible to make a photocopy of the images that you are sending out. The 200-watt bulb shines light through the transparencies, creating an image on the copy paper. By doing this, I am able to see exactly what photographs have been sent to a client, what caption information was on the slide, and whether the slide was an original or a duplicate (all my originals are stamped as such, and this information shows up on the photocopy). Ironically, only the smaller, cheaper personal copy machines are able to do this.

For editing my slides, I use a large light table that I made myself. I bought a 6-by-6-foot length of diffusive plastic at a local plastics store and wired up four daylight-corrected fluorescent light bulbs within a wooden box that supports the plastic. Good light tables can be bought commercially as well. The Accu-Light brand of light table is popular, relatively inexpensive, and comes

in long, 4-foot lengths. I bought two of these tables when moving into my new office last year. I ended up returning one and modifying the one I kept, removing the large black spacers on the edges and simply taping down the plastic to the metal table.

I recommend buying the longest light table that you can afford, as you will need space when organizing slides into a story or slideshow. You can buy color-corrected light boxes that cost hundreds or thousands of dollars; these are used for proofing images when color balance is exceptionally important. Whatever you do, don't buy a cheap light box that uses tungsten (household) lights. The color balance will be terribly wrong on these light boxes, as tungsten bulbs give off light that is orange in color. Your light box should use daylight-balanced fluorescent bulbs, and a light meter measurement off the light surface should give a reading that is close to daylight. For instance, a camera meter pointed at a light table should give a reading close to f/11 at ¹/125 if set to ISO 100 speed film.

I use a Peak 8× magnifying loupe to edit my slides on the light table. This is an inexpensive but very practical loupe, which costs less than $45. I prefer the Peak loupe (Product #8105), which has a rectangular area at the bottom that just covers the image area of a 35mm slide. Rodenstock, Hoya, and Schneider make 4× and 8× loupes. I greatly prefer the 8× loupes, which allow you to gauge the critical sharpness of a transparency. I have found that picture editors prefer 4× loupes, however, although I honestly have no idea why.

The final and most important piece of equipment that I have is a good slide-duplicating machine, along with a quality 1:1 enlarging lens. Unless I have a good working relationship with a client, I routinely duplicate my submissions and send out dupes rather than originals. I've been able to hold

down costs by duping submissions myself, and I use the special low-contrast duplicating films (Ektachrome 5071 and Fujichrome CDU) for the highest quality. These films need to be tested for color and exposure balance with each batch, so I buy the films in bulk and store them in the freezer until they are needed. The process of slide duplicating is shrouded in mystery, and it's possible to spend a great deal of money and time searching for that perfect dupe. Because duplicating your work is such an important and expensive proposition, I've devoted an entire section to the subject of slide duplicating.

Organizing Your Library
I have not completely computerized my office, and I have found that most successful photographers and agents have not com-

My copy machine and light. *You can make photocopies of transparencies only by shining a light through them as the copy machine is working.*

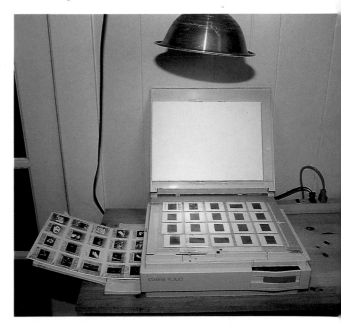

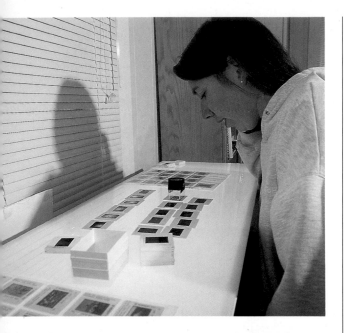

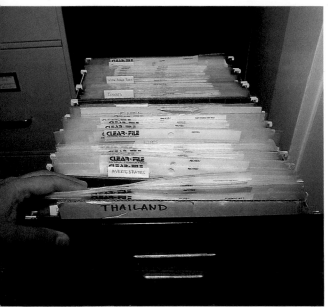

Kris Ingram working at the light table, with Peak loupe and slides.

One of my filing cabinets with hanging folders.

puterized their photo files. I use the computer to handle tasks such as invoicing, letters, mailings, and captioning, but not to keep track of every image in my library. Because my library has 250,000 images and is growing all the time, trying to catalog and computerize each image would be a near-impossible feat. Instead, I photocopy each submission of photographs to create a visual record of exactly what each client has. I have a manila folder for each client, and if the client is holding photos, then his or her folder is kept in the "slides out" filing drawer. My database program keeps track of the number of photographs that are out with any particular client. My client folders are filed under the same categories in which they are listed in my computer database: children's books, adult books, diving manufacturers, paper product companies, and so on. In this way the data in my computer mirrors the organization of my client files.

I physically organize photographs by location, broken down into categories such as fish, invertebrates, divers, and scenics. Each location is given a separate filing cabinet. Within each location, the subject categories are organized into separate hanging file folders. Within the hanging file folders, all photographs within that subject are kept in polyethylene vis sheets. I greatly prefer the slightly cloudy polyethylene plastic sheets (Clearfile Archival Classic pages, Product #21), rather than the too-slippery, but clearer, polypropylene plastic sheets. With this system, I can quickly scan pages of slides, twenty per sheet, until I find the slide that I want. Using vis pages within hanging files in standard filing cabinets is the only system I have ever seen in use at any agency, and I cannot recommend anything more highly. One book I read when first getting started recommended storing slides in boxes and using a projector with a stack loader to go through your slides. Throw that book away. File your slides in

vis sheets, twenty slides per page, and file by location. Forget those specialized slide-filing cabinets as well. Standard steel filing cabinets with frames to hold hanging files are all you need.

Here is an example of how I file my work. I recently returned from four weeks in the Galápagos Islands, with both underwater and topside images. I shot about 120 rolls of 36-exposure film during the trip. That is about 4320 images. After all the film has come back, I set aside two to three days for editing. I go through each roll of film and pick out the very best images, the ones for my files, which are used in my portfolio, books, and articles. I keep about 50 percent of the total images for my files, which is too much. (I have a hard time letting go of my babies!) Perhaps 25 percent of the images go into the trash because they are improperly exposed, out of focus, or just plain boring. The remaining 25 percent of my images go to my stock agencies. All the slides are filed by subject in the Galápagos cabinet, under the headings of "Fish," "Invertebrates," "Underwater Scenics," "Topside Scenics," "Birds," "Reptiles," and so on. For frequently requested subjects, such as sharks, I may place Galápagos images relating to that topic into that subject file rather than the location file. All slides in my files and that go to my agencies are stamped with my name and copyright symbol and year, in the form "© 1996 Norbert Wu." Since I move my office fairly frequently, and because no agencies want a photographer's address or phone number on the slides, that is all I put on the slide beyond a caption. I place captions on the photographs only when necessary—if a client needs it. The vast majority of the images in my library have seen the light of day only once—when I placed them on the light table for that initial edit.

If this sounds like a lot of boring, tedious work, you are right! If there is any secret to my success, however, it has been in the proper organization of my office, my procedure of duplicating submissions, and using the computer practically. By organizing my office efficiently, I am able to find photographs and make submissions quickly. By duplicating my submissions, my best shots are available for other prospects, and I don't need to worry about valuable originals being lost or held for too long. By using my computer practically, I spend less time learning nuances of a computer program and more time getting work done efficiently. Time is your most valuable asset, and these tips should help you save a great deal of this asset right from the beginning of your career.

Slide Duplication

When I first started marketing my work, I was faced with the problem that all photographers must eventually face: How can you send out your valuable original transparencies to a publisher who may hold on to them for months? While that publisher is holding your originals, they aren't being seen by other clients. You are therefore losing income from those slides that are out of your files. The only solution to this problem is to send duplicate transparencies rather than the originals.

I could tell dozens of horror stories about publishers and their mistreatment of my work. All of these stories boil down to one problem: Most publishers don't care about photographs or about your problems. All they care about is getting their publications out. This means that they want your photographs for as long as it takes to put the magazine or book together. The less hassle the photographer gives them, the better. The publisher who insists on originals and promises to get them back to you within two weeks is the one who will hold on to your slides for months. Never believe publishers when they promise to get an original back in two weeks. Two months, maybe. No publisher has ever returned my slide within two weeks, although several of them have promised. I've lost clients, even some good ones, when I held them to their promise. The quickest way to lose a client is by irritating them with repeated requests for the return of your photographs. You can lose clients by demanding your slides back too soon, too many times. The solution is to send out only duplicate slides, and to let publishers take their time with your work.

Another good reason to supply publishers with duplicate slides rather than originals is that just the process of reproducing a transparency in print form involves damage. The slide is removed from its mount, immersed in oils, and slapped onto a rotating metal cylinder called a scanning drum, usually by a printing company employee with a plumberlike disposition. The slides that come back from printers often are marked with fingerprints and scratches everywhere. My best sailfish shot, an extraordinarily rare and unique image, came back attached to an envelope with masking tape. The glue from the masking tape is still stuck on the acetate.

The Craft

The craft of making duplicate transparencies is shrouded in mystery. I have spent the last ten years researching, experimenting, and refining my approach to using and making duplicates, and the information in this chapter has been difficult and expensive to come by. I will describe how I am currently

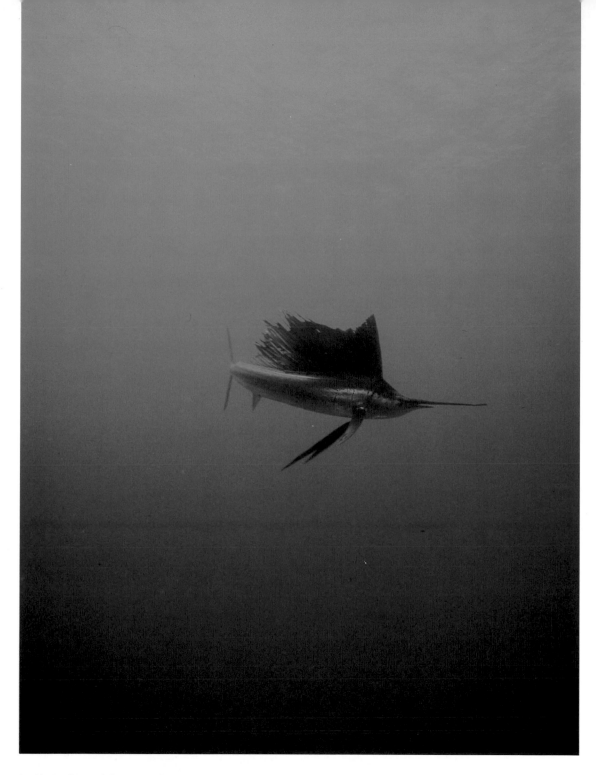

Sailfish, Sea of Cortez. *One of my most valuable slides, this sailfish image came back from the printer with masking tape all over it! I only send out duplicates of this image now.*

Dupes of the same shots in 35mm, 70mm, and 4×5, all at the exact size of the dupe itself. Eye of a sleeping parrotfish, Red Sea. *Here are examples of 35mm, 70mm, and 4×5-inch duplicates. The difference in quality between these formats is not great when printed at small sizes.*

making my 35mm duplicates: the film stock, the procedures, and the equipment.

Duplicate transparencies generally come in three sizes: 35mm, 70mm, and 4×5 inches. The difference in quality of the final published image from each size of these dupes can be remarkable. The quality of the dupe can depend on the technique and equipment used to create the dupe as well. I produce only 35mm duplicates in my office. If larger formats are requested by my clients for reproduction, I send my originals to a professional laboratory for duplication. I have found that 35mm duplicates work just fine for most magazine reproductions up to half-page size. For projects using my images up to full-page size, I will supply 70mm duplicates made by a professional lab for printing. Anything larger requires a 4×5 duplicate. Dupes cost about 30 cents per homemade 35mm dupe, $1 to $2 per lab-made 35mm dupe, $6 to $10 per 70mm dupe, and $20 to $45 per 4×5-inch dupe.

Making your own 35mm duplicate slides is neither difficult nor expensive. To get the best quality possible, however, you have to buy the best lens and equipment for the job. Manufacturers such as Bowens (marketed in the United States by Bogen) and Beseler make $1500 slide duplicators that feature many bells and whistles. The basic idea of a slide duplicator is simple. The original slide is mounted over a light source, and a camera takes a picture of the slide. The Bowens unit features a modeling light that is used to focus and a flash unit that actually exposes the slide. You must add separate color gel filters to match colors and compensate for the duplicating film's color balance. The Beseler unit features both flash and tungsten exposure capability and has dichroic filters that can be dialed in. The Beseler unit is superior to the Bowens unit because of the dial-in color filtration and the tungsten light source. Contrast is a problem when duplicating slides,

and duplicating film created for use with tungsten lighting is inherently lower in contrast than duplicating film used with flash.

The problem with both of these expensive units is that the bellows unit attaches the camera and lens directly to the light source. The motion of the cooling fan causes the light source to vibrate, and this vibration is transmitted and magnified to the camera-and-lens combination, which sits on top of the tall bellows column. For the long 1-second exposures necessary for exposing the tungsten-lit original, this vibration results in an unsharp slide, indiscernible with a loupe but evident when the dupe is printed. Because the flash freezes motion, it is the preferable light source for duplicating slides on these machines. Unfortunately, using a flash source will create a dupe with excessive contrast.

The solution is to separate the light source from the camera-and-lens combination and to mount the original slide directly to the bellows, separately from the light source. This is exactly how Nikon and Canon make their slide-copying attachments. I have gradually discovered what I believe is the best equipment for Canon and Nikon users. I started with a Canon bellows unit and 50mm macro lens, with a Canon slide copy attachment that mounted to the end of the bellows. This gave me a firm, steady camera-lens-slide combination that I could point at a separate color enlarger head to make a tungsten-based exposure. Since the slide and camera were not attached to the light source, vibration was not a problem. After further research, I bought a lens that is specially designed for 1:1 reproduction—a $500 Rodenstock APO Rodagon (Beseler) 75mm f/4 lens. This lens gives sharper dupes than a macro lens. I was able to find a Canon lens mount converter type A, which allowed me to use the 39mm Leica threaded Rodenstock lens directly on my Canon bellows. I used a

Canon F-1 body, which gave me a 100 percent viewing area, extremely important in slide duplicating. When I began using Canon EOS cameras, a Canon FD-to-EOS lens mount converter allowed me to use my Canon bellows with an EOS-1 body, which also shows a 100 percent viewing area.

When I switched to Nikon bodies two years ago (because I shoot underwater, and the Nikon system works well underwater for a number of reasons), I was forced to use the Nikon bellows and slide attachment along with an F4 body, the only current Nikon body that shows 100 percent of the viewing area. The Nikon bellows and slide attachment are not as well made as the equivalent Canon gear. The slide moves around with a great deal of slop within the copy attachment even when the mechanism is locked down, which was not a problem with my Canon gear. I also had a hard time finding a way to mount my Rodenstock lens onto my Nikon bellows. The Nikon part that facilitates this is listed in the catalog but is not being made. I wasted weeks before finally finding a solution, suggested by Ken Hansen Photographic in West Palm Beach, Florida: a combination of a Nikon-to-T-mount converter, along with a T-mount-to-39mm (Leica) thread converter.

It's not often that a less expensive solution to a photographic problem gives higher quality, but that's what happened in this case. You can buy a used color enlarger for under $250 and obtain the capability to make color prints as well. The best color enlargers have dichroic filters built in, so that you can simply dial in color values. Alternatively, you can use a black-and-white enlarger and buy a set of color gels, which you place over the light source.

You need a color head to make your duplicates, because each emulsion of duplicating film varies in color balance. I buy my duplicating film in bulk, about a dozen 100-foot rolls at a time. I make sure that all rolls are from the same emulsion number and therefore react to light consistently. Both Kodak and Fuji make special low-contrast duplicating films. Kodak makes Ektachrome 5071, 8071, and SO-366 duplicating films. The 5071 film is for normal duplicating with tungsten light sources; 8071 is specially made for duplicating Kodachrome films; and SO-366 is made for electronic flash sources. Fujichrome CDU film, which I use, is designed for use with tungsten light sources. The Kodak 5071 and 8071 films list an optimum exposure time of 1 second, and the Fuji CDU film gives "excellent performance in a wide range of exposure time from $1/100$ sec. to 10 sec." I generally keep an exposure time of 1 second for CDU film, which gives me an f-stop of f/11 on my light head.

Subtractive Colors

Each roll of duplicating film lists a recommended filtration value. For example, my current batch (#391-008) of Fuji CDU duplicating film lists a recommended filtration of 55C 15Y. Because the light bulb in my enlarger is different from previous bulbs and from other people's equipment, this recommended filtration only gives a starting point. I have to run a test roll, varying my exposures and color values, to find the color filter pack and f-stop that best match this batch of film, on my particular enlarger, with this particular light bulb. If the light bulb burns out, then I have to run another test, as each light bulb gives off a slightly

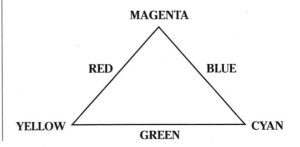

different color. As the light bulb gets older, it gets yellower, so I sometimes have to change my filtration values even with the same bulb and batch of film.

To test your batch of dupe film, you must understand the theory of subtractive colors. On your enlarger head will be three different dials: one for yellow, one for cyan, and one for magenta. Combining yellow and cyan gives the primary color green; combining cyan and magenta gives the primary color blue; and combining yellow and magenta gives primary red. Taking away magenta is the equivalent of adding yellow and cyan, and thus is equivalent to adding green. The accompanying diagram shows the relationships of colors. It takes some practice to recognize if a slide is too cyan or magenta. I learned to judge colors by printing color prints in a school darkroom.

Another property of subtractive colors is that the three subtractive colors combined will cancel each other out. Therefore, a filtration setting of 10Y 10C 10M is equivalent to 0Y 0C 0M (but a bit darker); a filtration value of 15Y 25C 5M is usually expressed by subtracting the lowest value, in this case 5M, from the remaining values, giving a filter pack of 10Y 20C 0M, usually expressed simply as 10Y 20C.

To test a batch of dupe film for proper color filtration, you must first create a proper test slide that will serve as the basis for comparing your dupes. This test slide should be photographed on the film that you use most, and it should contain skin tones, a gray card, and a pattern of colors. I've included my test slide here.

On my Omega enlarger with a tungsten halogen bulb, I have found that an exposure time of 1 second with an aperture of f/11 gives a good starting point. I also knew from previous batches of film that an exposure value of 45C 0Y 0M would put me close to the right value. With this new batch of film, I ran the following test (page 28) by varying

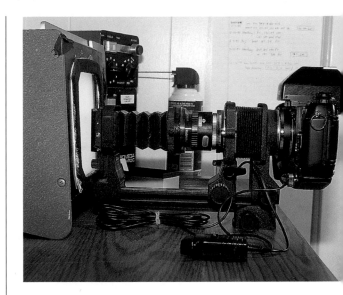

My slide-duplicating setup. *A Nikon camera attached to a Nikon bellows and slide copy attachment, pointed at a color enlarger head.*

filtration values and exposures, one variable at a time.

This test is meant to find the filtration values and exposure that create a duplicate that most closely resembles the test slide in color and exposure. I found that an exposure of f/11 1/2 and a filtration value of 50C (also represented as 50C 0Y 0M) rendered a dupe that most closely resembled the original. This is for the batch of film that gave a recommended filtration value of 55C 15Y. For my enlarger and light bulb, then, the color correction factor would be −5C −15Y. For example, my next batch of duplicating film gives a recommended filter pack of 45C 20Y; adding my correction factor gives me my starting point for a test: 40C 5Y.

Larger Dupes

For my coffee-table book *Splendors of the Seas,* I ran a test comparing laboratory-made 70mm duplicate transparencies,

(a)

(b)

(d)

(e)

(c)

(f)

Test slide and various color combinations.

(a) This is the original test slide. The best dupe should be as close to this in color and exposure as possible.

(b) 50C 0Y 0M: This was the best combination of filtration, which I found by dialing in different color values as below.

(c) 65C 0Y 0M: This slide has too much cyan.

(d) 40C 0Y 0M: This slide has too little cyan, resulting in a slide that is too red.

(e) 55C 10Y 0M: This slide has too much yellow.

(f) 55C 0Y 10M: This slide has too much magenta.

which have become popular in the past few years with stock agencies and photographers. They can be made inexpensively while giving a reasonably high quality. I contacted six different labs around the country, recommended by various photographers, to create 70mm duplicates for six different originals. I then had Faulkner Labs in San Francisco create 11×14-inch type R prints directly from these dupes to compare the sharpness and color rendition. The best of these dupes were also printed by the book's publisher along with the originals. The results were striking and informative.

Among the 70mm duplicates, no lab was consistently sharper or better color-corrected than others, although the Darkroom in Northridge, California, and PhotoCraft in Boulder, Colorado, seemed to have the sharpest dupes. Comparing the printed results from the original slides and the best 70mm duplicates showed that originals provide better reproduction quality than any duplicate. The printed pages made from the

slide #	filtration value		slide #	filtration value	
1. 45C 0Y 0M, f/8			18. 45C	0Y	5M
2. 45C 0Y 0M, f/8.5			19. 45C		10M
3. 45C 0Y 0M, f/11			20. 45C		15M
4. 45C 0Y 0M, f/11.5			21. 45C		20M
5. 45C 0Y 0M, f/16			22. 45C		25M
6. 45C 0Y 0M, f/16.5			23. 45C	5Y	0M
7. 45C 0Y 0M, f/22			24. 45C	10Y	
8. 20C 0Y 0M, f/11			25. 45C	15Y	
(all the remaining dupes were exposed at f/11)			26. 45C	20Y	
			27. 45C	25Y	
9. 25C 0Y 0M			28. 35C		10M
10. 30C 0Y 0M			29. 35C		20M
11. 35C 0Y 0M			30. 55C		10M
12. 40C			31. 55C		20M
13. 50C			32. 35C	10Y	
14. 55C			33. 35C	20Y	
15. 60C			34. 55C	20Y	
16. 65C			35. 55C	20Y	
17. 70C			36. 55C	30Y	
			37. 55C		30M

originals were sharper and had a much clearer tonality than the pages made from the dupes. My publisher put it this way: "While the pages printed with the dupes looked good, the originals produced results that were far and away the best." As a further test, Faulkner Labs created and tested 4×5 duplicates. These duplicates produced prints that were better than any of the 70mm dupes, although they still did not approach the quality of prints produced by originals.

Contrast is an unavoidable problem with duplicates. You can buy special contrast-reducing attachments for your lenses or try methods such as fogging film, although none of these work well, in my opinion. I just use the special low-contrast duplicating films, and I use my originals if highest quality is needed for reproduction.

The difference between dupes of different sizes and the original is extraordinary in contrast, tonal range, and sharpness. You can't compare sharpness of a dupe and the original by examining them with a loupe; you must go to printing. In the end, there is no substitute for an original. Only you can make the decision if the usage and fees warrant it. I never allow my best originals to be used unless the price of the usage warrants it or the project itself warrants it. For instance, I use 70mm duplicates for my children's books and for the vast majority of stock usages I am paid for. For my general submissions, I routinely send out 35mm duplicates. My coffee-table book, however, which I considered my most important project in ten years of photography, was printed entirely from originals for the highest quality in reproduction.

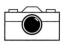
Markets for Your Photographs

There are two general ways that you can market your images. You can devote a great deal of time to market your images yourself, or you can have a stock agency market the images for you. Most photographers do both, but there really is no better way. I enjoy running my own business and handling the sales aspect of my photography business. I spend a great deal of my time cultivating clients, making submissions, tracking invoices, and handling business. Running your own office takes organization, professionalism, and a great deal of your time. The advantages are that you are in control of your own destiny, and you have a finger on the industry, thereby developing a sense of which images and subjects will sell. You control the use of your images, your personal contact with clients may lead to assignment work, and if you are professional and easy to work with, you will find that your clients and contacts develop into a network, many of whom will refer other clients to you.

There are many disadvantages, however. Running your own office is extremely time-consuming. Nearly all of your waking hours will be consumed by paperwork, telephone conversations, and contracts. You will end up with much less time to shoot photographs. Most photographers don't like running a business. Negotiating prices with clients makes them uncomfortable, or per-

haps they are not organized enough to run their own businesses. They may prefer to travel and shoot more often. For these photographers, using a stock agency may be a good choice.

Stock Agencies

When I first started thinking about becoming a professional photographer, I was awed by the photographic galleries around Northern California, where I went to college. Having a collection of magnificently framed images exhibited in such serene, classy surroundings seemed to be the epitome of success. I worked hard at getting my photographs in galleries, spending several months of my life buried in a color darkroom making Cibachrome prints and learning how to best mat and frame them. After a full two years of working on prints of my underwater images, I managed to put on several shows at local museums, sushi bars, and galleries. I was accepted at a gallery across the country, in tony Provincetown, Cape Cod. I even sold a few prints.

Pursuing the gallery and fine-art photography market was one of the biggest mistakes in my career. My time would have been far better spent shooting new images and pursuing other markets. To this day, I have problems with my inventory of framed and matted photographs. There isn't enough

space on my walls to hold all of them, even though I've given most of them to my mother, who has a much bigger house. I've even given prints to my sister. In fact, if you make the slightest sign of appreciating one of my photographs while you are in my house, you may be the recipient of a framed Norbert Wu Cibachrome print. After graduating from college, I moved around a lot, which is what young people without permanent jobs often do. I had to move the prints—frames, mats, and all—everywhere with me. Because I had spent so much time and money on them, I was reluctant to simply throw them away. Yet all of my efforts—my time, money, and enthusiasm—really went to waste. I made a few hundred dollars by selling a few prints, and I could still probably sell some prints if I worked at it. But the hassle far outweighs the income, and if you are a professional, that should be the primary consideration behind any endeavor you undertake. The gallery in Provincetown proved to be a complete boondoggle. I shipped the framed prints to them at my expense, they notified me that I needed to pay for glass broken in shipping, and I waited and waited for a sale. They held my prints until I sent money to pay for the glass, which they replaced at exorbitant expense, and then they never even put the prints on display!

Still, a few photographers do make a good living by selling prints. Tom Mangelsen, a wildlife photographer in Jackson Hole, Wyoming, had the inspiration to take displays of his photographs to several major airports. Now he has galleries exhibiting his work in several cities—all cities that have

Female lion lost from her pride during the night, surrounded by zebra in the morning, Kenya.

wealthy populations or attract wealthy visitors. His work is superb, his galleries are wonderful, and I am sure that he does well with this approach. Yet I would go broke trying this. The sad fact is that most people don't wish to buy photographs of fish for their walls. A magnificent photograph of a mountain landscape, a bald eagle, a wolf, a lion, or a cheetah, maybe, but not a fish, a moray eel, or an octopus. The market for underwater photographs is much smaller than that for topside wildlife photographs.

Stock agencies are much like galleries. If you are close to them, geographically or philosophically, you can do well with them. If they have a financial stake in selling your images, the chances are better that they will attempt to sell them. If you are far away or if you don't have a good rapport with them, they probably won't sell your images well. If you don't have the right images for the market or ones that fit the agency's specialty, then the images won't sell well. On the other hand, if you have the right images for the market, if you keep supplying the agency with what they need and want, or if you own your own stock agency, you probably will do just fine.

I believe that stock agencies are the most overhyped topic in the photography industry. Not a day goes by without a photographer asking me which agency he should go with, whether he should sign an exclusive contract with a particular agency, or why his work doesn't do well with an agency. Not a day goes by that I don't receive glowing reports from my agencies of five-figure sales of images of clouds or people. Not a day goes by that I don't hear about new catalogs, new promotions, new directions, new methods of marketing from my agencies. Don't get me wrong—stock agencies do represent a steady stream of income for me, and they have made a few photographers a very good living. However, all of my twelve United States and foreign agencies combined make

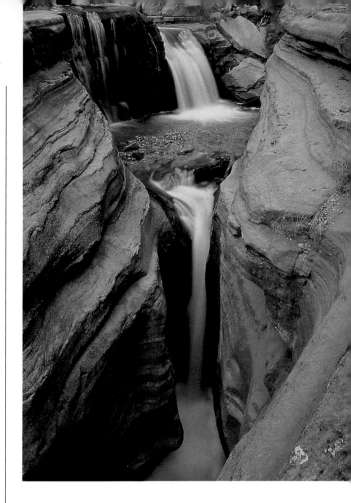

Deer Creek, Arizona. *A print of a landscape or a familiar animal will sell far better than a photograph of an octopus or moray eel.*

only about 20 percent of what I make myself, in my small office. Of course, everything that I say here applies to my experience as a wildlife and nature photographer specializing in underwater photography.

Over the years, I've learned to take everything that my stock agencies feed me through their newsletters, want lists, and letters with a healthy dose of skepticism. I've learned that most stock agencies will demand your time, waste your time, fritter away your time with little financial return. I'll outline here what I perceive to be the main issues with stock agencies I have worked with. As a stock agency owner

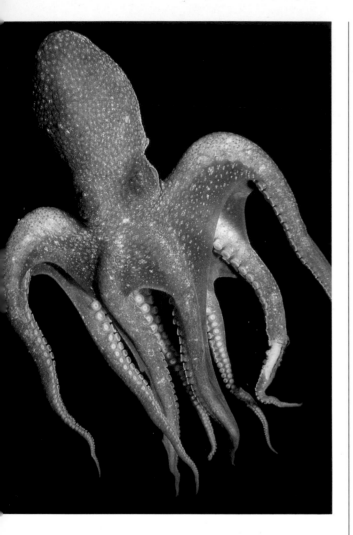

Deep-sea octopus swimming, California. *Few people would want a photograph of an octopus on their walls. This photograph has sold repeatedly to magazine and book publishers, however.*

myself, I know these issues from both sides of the fence.

Let's start with some basic information. The stock agency is simply a library of photographs from many contributing photographers. An agency may include anywhere from one to hundreds of contributing pho-

tographers, and agencies may represent as many types of work as there are photographers. Agencies simply sell the rights to use a particular photographer's images at rates and methods of their choosing. Ownership and copyright of the photographs deposited in the stock agency's library remain with the photographers. The idea behind a photographer–stock agency relationship is simple: The photographer sends periodic submissions to the agency, from which the agency makes a selection for its files. With these images in its library, the stock agency makes sales that are split fifty-fifty with the photographer. Some agencies differ in the split, but fifty-fifty is standard in the industry. The photographer invests time and money in producing the photographs, and the agency is responsible for the costs of doing business on their side. In an ideal relationship, the stock agency actively markets the photographer's work, leaving the photographer free to pursue assignments or other activities. Both parties benefit, and the stock agency may provide anywhere from 1 to 100 percent of the photographer's gross income.

To many photographers, the idea of having stock photographs bringing in money with little effort on the photographer's part is enticing. In actuality, however, a relationship with a stock agency can require a great deal of the photographer's time and lead to few or no sales. Shooting for stock is as difficult as assignment photography, if not more so. A good stock photograph must exemplify the most ideal values of a scene or emotion. For instance, a good stock photograph of a couple walking along the beach of a tropical island must show clear, blue water; clean, fine white sand; and an attractive couple dressed in nondatable fashions. To compete with similar scenes, this photograph must be perfect in every detail, both technically and aesthetically. Stock photography at its best captures the essence of what an art director, editor, or customer

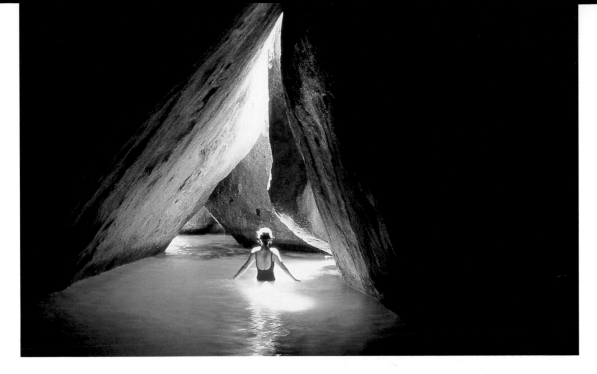

Model in the Baths, British Virgin Islands. *A photograph that includes a person or couple makes the image more salable. The best-selling stock photographs include people dressed in timeless fashions. Unfortunately, this also makes stock photography seem generic.*

British Virgin Islands advertisement. *Courtesy of the British Virgin Islands Tourist Board.*

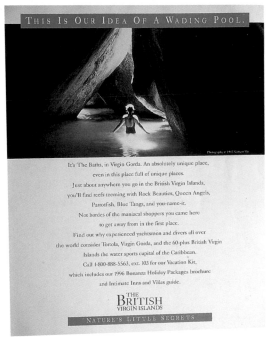

envisions of paradise, togetherness, or strength. To produce successful stock, a photographer must keep up with trends and market analyses to be aware of what makes a successful stock photograph. On the other hand, many successful stock photographs are simply unusual or unique, for example, photographs of endangered animals. Several wildlife agencies specialize in providing photographs to the editorial market, which is entirely different from the advertising and commercial market.

Exclusivity
If your work is of a sufficiently high caliber—and it need not be the best in the world—you will eventually find a stock agency that

will accept your work. If you specialize in a certain type of photography, such as portraits of people, wildlife, or underwater, chances are that you will be in high demand. If your specialty is one that most agencies don't have in their files, you will find it easy

Snow geese, New Mexico. *Photographs of wildlife that illustrate a concept—in this case, crowds—sell well as stock.*

to gain entry into the agency. The problem then becomes finding an agency that will actively market your images rather than sit back and wait for requests. I specialize in underwater photography, which is practiced full-time by only a few photographers in the world, and nearly every agency I have ever approached has offered me a contract. Most agencies, however, get only a few requests a year for underwater material, in comparison with people shots for advertising. No self-respecting agency ever wants to turn down business, so having underwater material in its files helps when those infrequent requests come in. The best agencies are those that actively push my material, rather than just sitting back and waiting for those few requests.

Most stock agencies will try to persuade the photographer to sign an exclusive contract in which the photographer can submit photographs only to that one stock agency. They may dangle enticements like the fact

that they have subagents in every country in the world, or that only their exclusive photographers are allowed to have photographs in their catalogs. Don't be lured by these promises. Subagents don't pay for their way after they have taken their cut and after your agency has taken its cut. Instead of 50 percent of a sale, you'll end up with only 25 to 30 percent. Exclusivity is too much of a one-way street. And in the most restrictive exclusive contracts, you can't even sell your own work yourself! Stock agencies have too much of a good thing with a photographer-exclusive contract. They demand exclusivity from their photographers, but they promise nothing in return—not money, and not even the promise of limiting the number of photographers in the agency or in your specialty.

If you know the game, you will ask for a contract that calls only for image exclusivity. In such a contract, your agency retains exclusive rights to market the specific images that they select for their files. You often can retain the rights to market those images yourself, as long as you do not interfere with your stock agency's market. The best type of contract gives exclusivity only

to those images that your agency selects for a catalog or other promotion. If your stock agency makes a financial commitment to one of your images by placing it in a catalog, you have more of a chance that the agency will sell that image. Unfortunately, many agencies charge their photographers exorbitant fees for including their images in catalogs. One photographer has calculated that agencies are making tens of thousands of dollars by charging their photographers for inclusion in catalogs, then turning around and selling those catalogs to their clients! The best agencies will pay for the catalogs in advance, and deduct the expense from future earnings of the photographer, only from sales of the images that are included in the catalogs.

Snorkeler at the Baths, British Virgin Islands. *Shooting verticals as well as horizontals will allow your photographs to be used in different ways, such as covers.*

British Virgin Islands brochure. *Courtesy of the British Virgin Islands Tourist Board.*

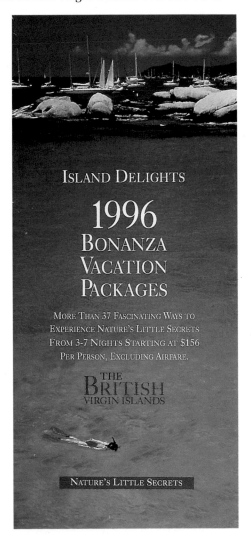

One of my agents recently brought up the fact that electronic catalogs, such as CD-ROMs, should be treated differently from normal paper catalogs. He had a point, and I was heartened to hear such an opinion from an agent. The cost of including an image on a CD-ROM catalog (as low as $1 per image) is much less than including an image in a print catalog (hundreds of dollars per image). If you give exclusive rights of your best images to an agent who pays only a few dollars to include that image on a CD-ROM catalog, then those images are lost to the rest of the world. The agent has less incentive to sell that image, since he only has a few dollars invested in it. I'm going to have to think long and hard about granting image exclusivity based on inclusion on a CD-ROM catalog from now on.

Choosing an Agency

The stock agent relationship should be thought of in terms of years, not months. It takes at least two years for your photographs to start making money for you in a stock agent's library. It is also up to you to keep sending in fresh material. The better stock agencies work closely with their photographers to review their work, market and duplicate their best work for worldwide distribution, advertise their work, and inform their photographers of frequently requested or needed photographs. Yet many of these agencies have often wasted my time.

For instance, I used to pay attention to want lists from my agencies. I'd go through their lists and go through my files to send them material on the lists. I even went out and photographed specifically for some want lists when I had some free time. It was supremely discouraging, after spending so much time fulfilling my agent's requests, to have the vast majority of my work returned. I've had urgent faxes from my agents asking for photographs to fill specific, urgent requests from ad agencies or magazines. After filling a few of these urgent requests and receiving nothing for my troubles, I stopped fielding specific requests from my agents. I wasn't able to charge a research fee for my time, which is standard practice when dealing with clients directly. If you have time to field specific requests from an agent, you'd be better off using that time to contact your own clients directly.

Koala with baby, Queensland, Australia.
This is a classic stock catalog image. It has sold over and over again after being included in one of my agency's catalogs. Like all good stock images, it evokes an emotion, in this case, through its cuteness.

Underwater sand dunes, Grand Cayman. *As a specialist in underwater photography, my images are often used to illustrate concepts in stock agency catalogs. This very basic image has been included in one of my agency's catalogs, and it brings in steady sales. The equivalent topside image would probably already be represented in most agencies.*

I try to deal only with agencies that respect my time. One agency required that I caption each photograph I submitted, before it made a selection. Captioning images takes an enormous amount of time. I tried all sorts of things to make this process easier, and I even hired a professional photo editor to go through my submissions so that I would submit only my best work to this agency. Even after her careful editing, however, this agency accepted only 5 to 10 percent of my edited, captioned submissions. After spending all this time and money on editing and captioning *before* the images were selected for the agency's files, I was not happy when 90 to 95 percent of the images were returned. It was this agency that sent me want lists of subjects and locations it wished to see, and subsequently rejected nearly all of my shots taken specifically for those lists. This agency required a great deal of my time and had little respect for my efforts, so I don't submit to it any longer.

The best agencies value your time and do not ask you to make large submissions unless there is a definite chance that the photographs will result in a sale. They won't ask you to caption your submissions before they choose them. They will accept submissions from you, select the ones they want for their files, then return those selects for you to caption. The best will handle most aspects of captioning in their office, thus ensuring a uniformity and efficiency of captioning that individual photographers can't be expected to fulfill on their own. If they promise to get an original back to you within two weeks, it will be back in two weeks, not two months. They won't ask to hold your best originals in their files for months or years. They will work with you to obtain rights to sell your best images by duping your valuable originals and returning the originals to you.

After many years of selling photographs on my own, I decided to invite a few photographers into my own specialized agency. I came up with some guidelines in the interest of fairness and with the idea that the agency should have some financial stake in its choices of photographs.

Because I want access to my photographers' best shots, I ask my photographers to send their best originals. I pick out the best shots from their submissions, make several duplicates of each chosen original, and return the originals within two to three weeks. By doing this I don't have to bother my photographers for the originals unless a client demands them for publication. I supply them with a photocopy of the images that have been chosen for my files, which allows both of us to locate specific images according to their position on this photocopied reference sheet. It is the photographer's responsibility to keep his originals organized and accessible in case a client requests the original for publication. In most cases I ask clients to use enlarged dupes for printing, but in those cases where the client insists on the original and the usage fee is high, I ask the photographer for the original. I make 35mm duplicates in-house, and we split these costs, which is only about 30 cents per dupe rather than the $1 per dupe that most agencies charge. I deduct the photographer's half of the duping costs from his first sale, so he never has to send me money. If I am requesting originals from the photographer, I give him my Federal Express account number to bill the shipment to. We split this cost, which is deducted from his future sales proceeds.

I've had some problems with these practices, which allows me to see the stock agencies' point of view. Competition is always a problem, so I can understand why agencies prefer exclusive contracts. If, for instance, I sell an image to a calendar and then find out that the photographer has already sold that image to another calendar company, my efforts have been wasted. There's really no good solution to this problem. I've had to drop one photographer from my agency. I sold one of his images several times, but each time he vetoed the sale. Finally he admitted that he had given rights to a very similar image (which means I can't sell his similars) over to a stock agency catalog. I had spent a great deal of time and energy duping and sending out his material, but it resulted in no sales, although the possibility was there.

Keel-billed toucan, Belize. *This image was used in a company's 1997 calendar. As such, I had to make sure that the image was not used in any other calendar for that year.*

I generally sell only one-time, nonexclusive rights to images. Certain types of publishers require exclusive rights in a certain market. For instance, calendar publishers require exclusivity of an image for the year that the image is being used in a calendar. In any such exclusive sale, I must clear the rights through my photographer before approving the sale. If the photographer does approve the exclusive sale, it is his responsibility to make sure that that image and similar ones are not sold to competing publishers or products. In all other cases, he is free to market his work independently. Some photographers have asked if my own photographs will compete with other photographers' work. The answer is that I am objective enough to recognize a photograph that is of high quality, and I will market that photograph over others of lesser quality. In most agencies, it is the best photographs that are submitted and that sell, regardless of any politics at the agency.

Business practices and work philosophies differ with each stock agency. One New York agency charges its photographers $2 for every photograph that is accepted for their files. Another agency in California charges $8500 for the costs of duplicating and sending five hundred of a new photographer's best images to their many foreign subagencies. I wouldn't touch those agencies with a hundred-foot pole, although when I was starting out, their hype attracted me.

Stock agencies can generally be divided into editorial and commercial agencies. As a wildlife photographer, I'd like my images to be in both types of agencies. Each agency has its own style, but it is important to find out what markets they aim for and how actively they market your work. The commercial agencies deal primarily with ad agencies and commercial products such as brochures for travel companies. Shooting for these agencies can be lucrative, but it can also be very frustrating. A good commercial stock photograph often must be better than photographs produced on assignment. Stock agencies in this market routinely produce slick mailings, huge catalogs, and talk of giant, five-figure sales. All these are part of the hype that is routine in the advertising game.

On the other hand, editorial agencies make hundreds of smaller sales a year. Their sales are slow but steady, and I've found that both types of agencies produce about the same amount of money for me. In fact, my main commercial agency, the one that I've had so many problems with in the past, has made several of my lowest sales to date. I routinely receive sales figures of $25 from this agency! They've always attributed the low sales to the fact that they sell through their foreign subagencies, which is a good reason not to allow your photographs to be sold through subagents.

Subagents

Subagents are simply foreign stock agencies that a U.S. stock agency has contracted with to license their images. The U.S. agency sends images to the subagent, which then sells rights to those images to its clients. The subagent takes from 30 to 50 percent of all sales, the U.S. agency takes another 30 to 50 percent of the remaining amount, and the rest is given to the photographer. Thus, with the typical fifty-fifty split each time, the photographer will receive only $250 from a $1000 sale. All the big commercial stock agencies have such relationships, and these subagents make sense in commercial markets, where most sales are of individual pictures. In all of my commercial agencies, however, the vast majority of sales are those made in the United States.

Allowing subagents to sell your work in editorial markets can actually hurt you. If you are an editorial shooter whose work lends itself to photo-and-text packages, you would be much better off finding an agency

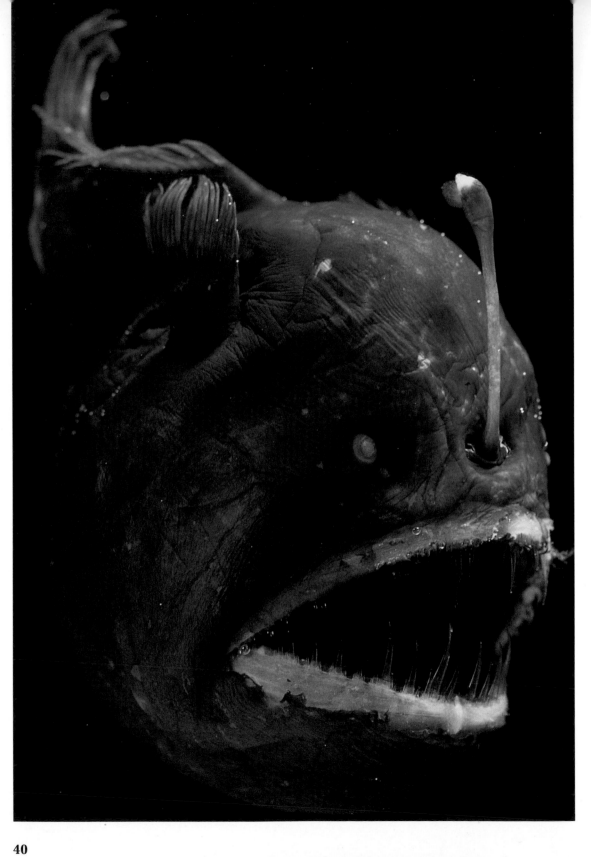

Deep-sea anglerfish. *Well-done portraits of animals that show bizarre or humorous expressions always do well. I never cease to be amazed at the selling power of this photograph. It has been featured on the cover of* Time *magazine, as well as on the covers of several other magazines and books, and has been used in advertisements to sell pharmaceuticals. It is almost invariably chosen to illustrate stories on deep-sea life. One of my present agents used it in a catalog of photographs called* The Stock Workbook, *which features the best that stock agencies have to offer in their files. Art directors and designers often use catalogs such as* The Stock Workbook *to stimulate ideas and select photographs for use in their projects. Many agencies are now producing their own glossy, expensive catalogs, hoping to enhance sales of any photographs included and provide greater business for the agency. Costs of being included in these catalogs vary from agency to agency. If I had given exclusive rights to market this image to my agency, I would have lost all the sales that I made of this image myself.*

or clients in foreign countries yourself and serving those agencies or clients yourself. One of my most popular stories, on deep-sea life, took off like a rocket a few years ago. Magazines from all over the world called me, asking for the story. If I had allowed one of my U.S. agencies to subcontract the story, I would have received only 25 percent of the sales, and I would have lost the personal contact with the magazines that benefits me greatly today. By selling the story directly, I retained 100 percent of the sales. With my agents around the world today, I can send them editorial photographs and keep 50 to 70 percent of the sale. It makes a big difference in my income, although it requires more organization, time, and effort.

Contracts can vary from a handshake or telephone agreement to a twenty-page tome. One worrisome aspect of any stock agency relationship is that none of them carry insurance for the photographs in their care. The cost of such insurance is just too high for them to cover your photographs, and as a consequence, photographs that are lost or damaged at the agency are rarely compensated for.

The dishonest stock agent is rare, but stories of "scam agencies" abound. Quite a few photographers question the entire notion of the honest stock agent. A very successful wildlife photographer sums it up: "I don't think that the agents start out by being dishonest. I think once in a while they forget to mail a photographer a check for something that's been sold, and then they realize how easy it is to get away with it." The best way to determine whether an agency is honest, aboveboard, and suited to your personality and business style is to visit its office and talk with the people in charge. Ask questions about the operation, and take time to go through the contract carefully. Many photographers have likened the photographer-agency relationship to a marriage. It pays to know who you're going to trust your invaluable images to.

Many aspiring photographers, because they've heard of photographs being sold for thousands of dollars, have a distorted view of the business of stock photography. In truth, the business of selling your stock photographs is tedious and time-consuming, whether you use an agency or sell your stock directly. I choose to use both avenues, because I want to sell my images to as many places as I can, to make as much money as I can. And most importantly, I want to have fun doing it; if I were only in business to make money, I might as well be slaving away on Wall Street, shuffling money from one account to another.

41

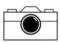

Strategies for Success

I have spent the past ten years building up a library of images from which I can draw on for my articles, books, and clients, which range from natural history museums to advertising agencies. In wildlife photography and my specialty, underwater photography, assignments are rare, so just about all of my income results from sales made from my existing library of images. In the course of carving out a niche in this specialized marketplace, I've learned a great deal about the market for photographs in general, and the principles I present here apply to all photographers who plan to sell their existing work themselves or through an agency.

Specialization

I teach one-day seminars on nature photography, and part of each class is devoted to a portfolio review. I've found, however, that just about every portfolio begins to look the same after a while. The portfolios invariably include close-ups of flowers, a few scenics of forests and mountains, and other pretty pictures. You could spend your whole life shooting flowers, scenics, and pretty pictures. They could very well be great shots, but you will most likely be stymied in your attempts to have these published. Unfortunately, it is hard for me to get my message across in one-day workshops. My two- and three-week-long workshops to places like

Africa or Antarctica are my preferred way of teaching, since I am able to see what each student is naturally inclined to do, and thus able to guide him to a subject or technique that makes his work special.

Different clients look for different things from photographers. Every nature photographer working today has his own special niche. Some clients, such as magazine and textbook publishers, need photographers with extensive knowledge of natural history. Other clients, such as those in the advertising industry, couldn't care less about the behavior of snails but are always on the lookout for someone who knows how to shoot tropical islands. The commercial photographer requires the knowledge of, and more importantly the interest in, dressing and setting up models. Other photographers make their living by teaching, selling art posters, or filming for television.

The best way to become successful as a nature photographer is to specialize in one subject matter or technique. By specializing, you will create a unique body of images that is much easier to sell than a general body of work. By becoming a specialist, you can create your own market, and you also become a photographer who is called by

Deep-sea fish photos.

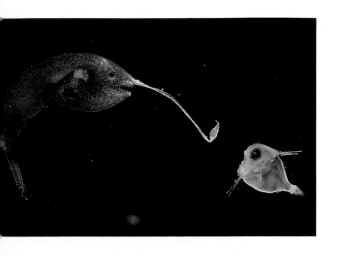
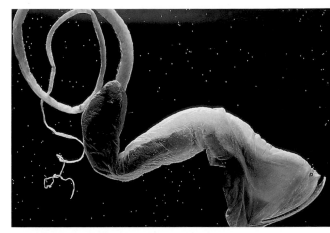
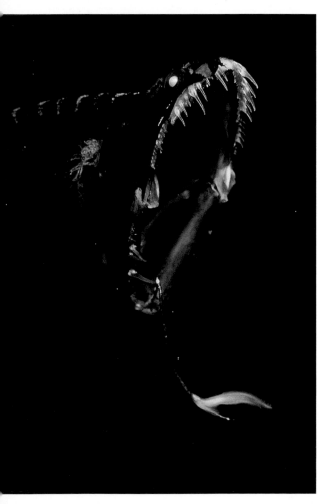

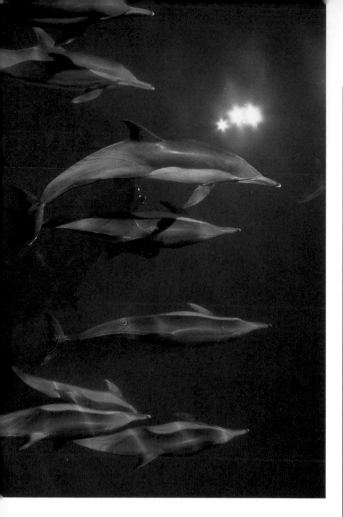

Common dolphins, Sea of Cortez, Baja California. *Marine mammals such as whales and dolphins have been recurring best-sellers. The problem is that so many good photographs of these animals have been taken. To reach the level of the current playing field, it is necessary to spend months photographing these unreliable, fast-moving, and politically charged animals.*

picture editors in need of particular photographs, rather than the other way around. This approach is the best way to get started in selling your work and building a portfolio that catches editors' attention.

Simply showing a different side to a standard subject can be successful. A recent *National Wildlife* portfolio featured a photographer who specialized in photographing wildflowers in motion. This photographer did not do anything revolutionary, nor did he require special equipment. The only difference between his photographs and the thousands of unpublished flower photographs was his specialization in technique and style. Instead of photographing wildflowers with high shutter speeds, he used a tripod and slow shutter speeds during windy days, to create an impressionistic, unusual look at the colors and motion of fields of wildflowers. The standard close-up of a flower became a study in color and movement, rather than a documentary shot.

We live in a complex world, where everyone is a specialist. But along with this specialized knowledge is needed a good dash of common sense. For instance, everyone knows that a Ph.D. is a good way to obtain a high-paying job. But woe to the poor Ph.D. student who has spent six years of his life specializing in a facet of analog engineering that has become obsolete in this day of digital electronics. I discovered after three years of effort that a Ph.D. in marine biology can only guarantee competition in the hundreds for a teaching or research position at a university, with a salary that is equivalent to the clerk's at the local hamburger shop.

Not all was lost during my years at Scripps Institution of Oceanography, however. During that time, I participated in a course on deep-sea life and went on several cruises, where I managed to photograph deep-sea fishes that were trawled up from thousands of feet down. Out of this two-year period of study and research, I created a story on deep-sea fishes. Although deep-sea fishes have been photographed by many different people, my photographs were complete and timely. More important, I was able to bring to the story a specialized and expert knowledge of my subjects. The story has been published in *Omni, Le Figaro,* and several other magazines and books around

the world. The individual photographs sell continually, and one of the photographs ended up on the cover of *Time* magazine in 1995. This project has been an astounding success, has earned me a great deal of money, and most importantly, has introduced my work to editors around the world, who now routinely call me with requests.

Other photographers, such as Frans Lanting and Fred Bavendam, have taken specific subjects such as albatross and giant octopus and created astoundingly successful stories out of them. Stephen Dalton specializes in "captured moments," using high-speed flash to capture animals in motion. Photographic subjects need not be rare or unusual. It is the complete behavioral story or the different technique that is successful, rather than the smattering of pretty pictures. Once you've attracted the attention of picture editors with a well-done, different essay, they will remember your name and call you with other everyday requests.

There is even a place for the standard shots of flowers. Gardening books and magazines constitute a bigger market than any other area of nature photography. A photographer with an expert knowledge of species and techniques of gardening will do well by building up a library of gardening photographs.

Do what you love, and the success will come. You just have to work real hard at it. Do what you're interested in, spend time

Bottlenose dolphin riding bow wave, Sea of Cortez, Baja California. *By using advanced photographic techniques such as rear-curtain flash sync, you can create photographs of animals that stand out from the usual shots. I used a combination of ambient light, a slow shutter speed, and rear-curtain flash to show the movement of this dolphin.*

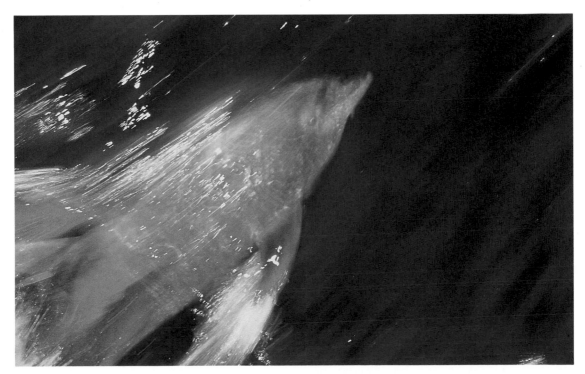

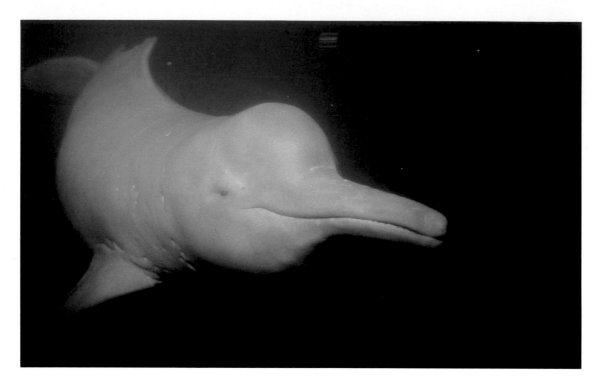

Amazon River dolphin, Pittsburgh Aqua Zoo. *The other approach to marine mammals is to photograph the less common species, the ugly ones that no one else thinks about. These photographs are in demand by book publishers that need to show the range and diversity of cetaceans. This photograph sells more frequently than any of my other dolphin photographs.*

documenting your favorite subjects, and don't waste your time shooting what you think someone else wants you to do. Spend time with your subject, shoot it in motion, stop it with flash, and shoot it every way possible. Bring a new look to a tired scene.

Obtaining Travel Assignments

I'm not a typical travel photographer. I'm known more for my pictures of wildlife and underwater subjects than my pictures of temples and portraits of people. Yet my business depends on my traveling to the far corners of the earth, on obtaining photographs of faraway places and subjects. In this past year I went diving and canoeing in Thailand, on safari in Kenya, swimming with

dolphins in the Bahamas, bird-watching in the Galápagos Islands, rafting down the Grand Canyon, whale-watching in Baja, trekking through rainforests in Costa Rica, and scuba diving in Honduras.

It sounds fun, and it was. It was also very hard work. An alternative but still accurate description of these trips would be that I almost died of heat exhaustion in Thailand, spent half my time pushing my vehicle out of mud in Kenya, spent much of my time in the Bahamas adapting to stormy weather and seasickness, almost died in the Galápagos after running out of air at 110 feet underwater, was so stiff after hiking down the Grand Canyon with heavy camera gear and an inadequate backpack that I could barely

Examples of my travel stories. *All of these stories involved great effort and little pay. The payoff has come years later, as I now have a library of images that I can use in my own and clients' books, talks, articles, and multimedia products.*

Sea canoeing through karst formations, Thailand. *This three-day canoe trip was perhaps the hottest trip I have ever endured in my life.*

Red-lipped batfish, Galápagos Islands, Ecuador. *In pursuit of a photograph of this bizarre, uncooperative little fish, I ran out of air at 110 feet.*

Eyelash viper, yellow phase, Costa Rica. *I took a photograph of this hard-to-find snake at a serpentarium in San José, Costa Rica. The difficult part of the shoot, however, was in making my way through the town of San José, a huge town with innumerable small streets and no maps. My terrible command of the Spanish language did not help.*

Bottlenose dolphins leaping, Roatan, Honduras. *I took this photograph only after enduring hordes of mosquitoes and no-see-ums.*

47

People pushing van out of mud in Kenya. *I traveled to Kenya in November, during the rainy season. It made for wonderful weather and rainbows, but I also spent a great deal of time pushing our and other people's vans out of the muddy roads.*

Coral Cay on the Great Barrier Reef, Australia.

walk the rest of the week, spent more money in Baja than I had bargained for, was lost for hours driving in the streets of San José in Costa Rica, and was eaten alive by biting insects in Roatan. If I were a typical tourist or amateur photographer, my travel costs would be prohibitive, and I would probably be out of business. Fortunately, there are as many ways a professional photographer can get to places as there are destinations. There are various ways that a professional photographer can obtain free or greatly discounted travel and accommodations.

I might as well shoot down the myth of a dream assignment at the beginning. It would be nice if a magazine would simply call me up and pay all my expenses plus a hefty day rate to photograph wildlife in Africa, but the fact is, almost no magazines do this. If you are well connected, politically savvy, and good enough to break into the ranks of *National Geographic* shooters, then you don't need to be reading this section. The rest of you should read on to see how the business of travel photography works for real photographers.

Every country that has a tourism industry has a tourism office somewhere. It may be in New York, Los Angeles, or in the country's capital, but the first step in obtaining an assignment to that country is to contact its tourism office. The second step is to work with a magazine—to get a magazine to extend a commitment for you to photograph or write about that destination. For example, the state of Queensland sponsors several press trips a year to northern Australia. Each press trip is oriented to a different specialty group: There's a week for scuba divers, one for newlyweds, one for clientele of cruise ships, and so on. There are as many different types of press trips as there are specialty magazines on the newsstand. The key to getting on one of these press trips is to develop a reputation as a photographer in a specialty and to develop a good relationship with the editor or director of photography at a spe-

cialty magazine. I was sent to Queensland by a diving magazine that I contribute to regularly. The Queensland Tourism and Travel Corporation invited writers and photographers from several diving magazines, and several of us traveled together.

Giant humphead wrasse, Great Barrier Reef, Australia.

Coral trout being cleaned by a cleaner wrasse, Great Barrier Reef, Australia. *I took all these photographs on a diving trip sponsored by the Queensland Tourism and Travel Corporation, one of the most professional tourism agencies in the world. I've also traveled to places where the tourism boards completely forgot or did not bother to arrange any part of my trip, making the trip both fruitless and expensive.*

For this type of travel assignment, the tourism office usually arranges to pay for all expenses, including airfare from your hometown, all meals, and accommodations. Infrequently, you will have to pay a nominal sum for expenses, meals, or to travel to a connecting airport. For instance, in countries that cater to the European set, lunches are often at your expense. You are treated well, placed in top-quality accommodations, and taken to see the most popular tourist attractions. This is, of course, because everyone involved wants you to have a good time so that you will write a good story about your experience. The downside of these press trips is that they can get old quickly. As an underwater photographer, I need plenty of time at a particular place to produce my photographs, and most of these press junkets don't give me enough time to even prepare my cameras properly before I am whisked off to another tourist attraction. I have heard horror stories from other photographers who were invited to places like Guam and the Philippines, where the tourism offices don't have the budget and organizational skills of the Queensland Tourism and Travel Corporation. These photographers were stranded at airports, stuck in third-rate hotels, and generally forgotten.

Another way to travel to your dream destination is to work with a tour operator.

Salt-water crocodile, Queensland rainforest, Australia.

Rainbow lorikeets, Queensland, Australia.

Eastern grey kangaroo with joey, Queensland, Australia. *The sponsorship for the Queensland dive travel story did not give me enough time to create a strong story on Queensland's wildlife. I took these photographs at my own expense after the sponsored trip.*

Many of the top nature and travel photographers work with tour operators that specialize in destinations like Antarctica, East Africa, and the Galápagos. Unfortunately, the field here is fiercely competitive, and most travel agencies will not send you to a destination unless you can offer something in return that they can't get easily from their other shooters. Their brochures and catalogs are already filled with photographs from their clients and staff, so they rarely need these kinds of shots. What every travel agency *does* need is a trip leader, a

51

person who can collect the money and bring a group of friends, students, or associates to a destination. If you are an instructor of photography at a local college, if you teach scuba diving, or if you preside over any kind of club, then you can approach a travel agency about taking your group to a destination. Rates and commissions vary with the size of the group and the situation, but you should expect to make a decent amount of money and have your expenses paid for your trouble. *Trouble* is the operative term here, because serving as a trip leader is asking for a great deal of pain and hard labor. Problems will arise at every corner, your clients will complain about nearly every possible situation, and things will almost always go wrong. If, however, you've picked the right place to travel to, the wildlife, scenery, and photography will make it all worthwhile.

My trip to Socorro Island off the coast of Baja California, Mexico, three years ago was typical. A group of divers asked me to charter a boat to Socorro, promising that they would be able to fill the boat. After getting in touch with the boat owner (a difficult job in itself, as he is virtually impossible to reach), I reached an agreement with him about dates and prices. Six months before the trip, the divers canceled on me. I was now left with filling the entire boat on my own, as it was too late to back out of my agreement with the charter boat captain. I found another group of divers, and after a great deal of chewing my nails, I finally received word that the Mexican government had issued permits for the boat to travel there. The trip could not have started out worse. A fierce rainstorm washed out all the roads in Cabo San Lucas, and our group had to drive all night to get to La Paz, where the boat was berthed. One couple had committed the cardinal sin of checking their luggage all the way through from Dallas to Cabo San Lucas, when they were transfer-

Photographs from Galápagos. (pages 52–54)

Tourists and trip leader, Galápagos. *Bringing a group of photographers and nature lovers to a destination is a good way to get yourself there. It can be hard work, however. Finding the right operation that has a good staff that can take some of the load off your shoulders will help free up some time for your own photography.*

Masked boobies in mating dance, Galápagos Islands, Ecuador.

Marine iguanas basking in the sun, Galápagos Islands, Ecuador.

ring airlines in San Diego. They were ready to quit after the first day because their luggage was lost. Tired and depressed, we traveled all night to reach Cabo San Lucas by water, where the luggage miraculously appeared. From then on, the trip was magic. We danced with dolphins, swam with sharks, wallowed with whales, and marveled at mantas. I am returning this coming fall, but my fingernail biting is starting again. The Mexican government would not issue permits for any boat this year!

Young Galápagos sea lion yawning, Galápagos Islands, Ecuador.

Sally Lightfoot crabs on lava coast, Galápagos Islands, Ecuador.

If you do obtain a letter of assignment from a magazine, keep in mind that any promises you make to the tour operators about mentioning them may not be honored by the magazine in which the article appears. I always make it a point to acknowledge the people and operations who have assisted me in my travels, but most magazines have a policy against mentioning names of specific tour operators and airlines in editorial articles. This can get a photographer or writer in hot water with the airline or travel agency that sponsored his trip. I always make sure that the tour operators and airlines that are hosting me understand that I do not have control over the editorial process. I also make it a point to ask the

magazine to print my acknowledgments to tour operators at the end of any articles that appear. This request is usually granted.

I find myself constantly having to overcome obstacles and attitudes that have come about by photographers who have preceded me. These photographers promised to send photographs to their hosts, promised to write an article about their travels, and promised other things that they failed to deliver. As I've become busier and busier, I understand how difficult it can be to honor such seemingly small details as sending prints to my subjects, but I've also seen the results: The failure of one photographer to live up to his promises makes it harder for every other photographer coming after him. The same thing happens regu-

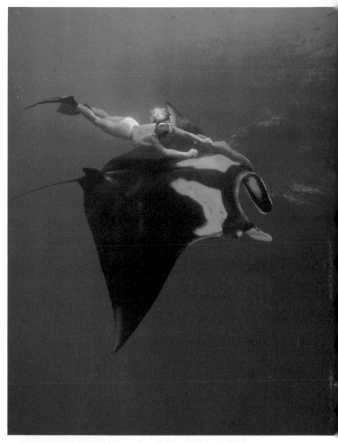

Photographs from Socorro.

Swimmer riding friendly manta at seamount, near Socorro Island, Pacific Ocean.

Sperm whales, near Socorro Island, Pacific Ocean.

School of stripe tail aholehole among huge waves, near Socorro Island, Pacific Ocean.

larly with airlines and tourism agencies. Many of the public relations people there have had bad experiences with photographers who have not delivered what they promised, and when I approach them, they are cynical and distrustful.

Photographers have a responsibility to their peers and their clients to live up to their promises. I make it a point to promise only what I can deliver, and over the course of many years, this policy of honesty has created a number of clients that can vouch for my work and vouch for the fact that I will publish an article about the destination that I visit. I also often bring a group of photographers or divers back to the destination, using the same contact that helped me in my first trip. This way I make some money by bringing a group, I am able to market the destination because of my expertise, and everyone benefits. This is a good way to make friends in the travel business.

By the way, I never sell my stories or photographs for free, or even for a discount. Getting those stories required a great deal of hard work on my part, and I expect to be paid at industry standard rates for any usage in magazines. Here is a typical scenario: The tour operator that sent me to the Galápagos calls up and asks me to send photographs to a travel magazine for a story. I send the photographs, and the magazine calls up and wants to use the photographs on its cover and inside for a six-page story. Unfortunately, the magazine doesn't have a large budget and wants to use the photographs for free. In exchange, it offers to mention the tour operator's name in the article, and says that this will give me great exposure. This is a tough decision. If I accept, I am selling myself as well as other photographers short. If I don't accept, then the tour operator doesn't receive publicity that he could have received. I solve this

dilemma in advance by explaining this possibility and my position to my client (the tour operator) in advance. I know that my work will eventually be published in another magazine, and I will not accept a rate that is below industry standards.

Here's another scenario: You are trying to sell your story to your magazine clients. (Yes, you can sell the same story to different magazines, as long as the magazines are in different markets. For instance, my story on the Seychelles has sold to diving magazines, natural history magazines, travel magazines, and magazines in the United States, Italy, Spain, and Germany.) Several of the magazines that you approach have already obtained your photographs from the tourism office for free, however, and they don't wish to pay for your story. This can be a problem for the beginning photographer who loans his photographs to a tourism office in exchange for a trip. The tourism office sends these photographs to every possible venue, seeking publicity. Your own photographs from the tourism office end up competing with you! I solve this problem by asking the tourism office not to send photographs for press releases

Aggressive male lion, Kenya. *In most photographs, and particularly shots in which the main subject needs to look imposing, an upward angle is best. I mounted a camera with a 20mm lens on a pole to get a different perspective of this lion. The camera is on the ground, below this lion, looking up. If I had been shooting down on the lion, it would not have looked as ominous. With today's autofocus, electronic-everything cameras, taking this kind of shot is easy. The autofocus lens focused on the lion, and I operated the camera with a remote cord.*

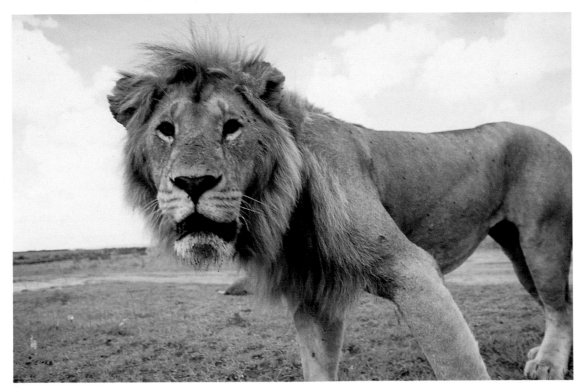

Grizzly bear in sunset light, San Diego Zoo. *This shot of a grizzly bear is another favorite of my agency's. Portraits of animals that are symbols are always popular. The grizzly symbolizes strength and "the call of the wild." This also shows that you do not need to travel to exotic locations to shoot high-selling photographs.*

or stories unless I have given permission in specific instances. If one photograph is used at a small size, to announce a specific event, then I will grant permission to use that photograph in a press release.

Composition

Composition may be the hardest part of photography to learn. Every person has his own way of looking at things, and it is often hard to explain why one photograph of a flower is so much more exciting than another. Isolating a subject from a jumbled background and placing that subject in a well-designed photograph require com-

mand of technique as well as an aesthetic sensibility. A photographer must narrow his vision to pick the best subject for the situation. The best photographs convey a mood, tell a story, or show the patterns and abundance of life. While there are no fixed rules for composing a photograph, a few ideas and considerations should be kept in mind.

Keep the photograph simple. I adhere to the "keep it simple" philosophy in both my photography and my gear. Fill the frame with your subject. In wildlife portraits, make sure that the subject is facing you and that the eyes are in sharp focus. To give more impact, try to get below your subject and shoot up.

Elements of Design

Negative space is the area of the photograph that is not part of the subject. Negative space can be as important as the subject itself. More often than not, it is the negative space that attracts me to a scene rather than the subject of the photograph itself. Photographs in which the subject is surrounded by pure black negative space are common close-up shots, and black backgrounds are always dramatic. Placing a subject in the middle of a scene of bright colors also makes for a visually stunning photograph. When I am shooting, I am always looking for brightly colored backgrounds against which I can place a subject. I look for both color and contrast separation, in which different colors or backgrounds make the subject jump out.

Diagonal lines leading through a photograph create a sense of tension. Other elements of design include S curves, in which a line winds through the frame, leading the viewer's eye.

The rule of thirds gives positions at which to place your subjects within the photographic frame to give them more power. To use the rule of thirds, divide the frame both horizontally and vertically into

Crab spider on flower blossoms, Kenya. *These flowers were not that interesting in and of themselves. I searched the blossoms around my hotel room until I found something that would make a photograph of them stand out. A tiny spider, waiting in ambush among the blossoms, fit the bill. I placed the spider at the top right corner of the frame, which makes it appear to be entering the picture. A photograph of the blossoms or the spider alone would not have worked nearly as well.*

Diagram of grid, showing rule of thirds.

Bat stars among intertidal algae, Monterey, California. *Tidepools can be some of the most difficult places to photograph. The many different forms of life can lead to confusing, jumbled photographs. I searched this area at low tide until I found a composition that eliminated distracting elements. I then positioned my camera on a tripod to take advantage of the curves flowing with the eelgrass. The winding S curve is a strong yet subtle element in many of the most accomplished photographers' work.*

thirds, with two lines crossing the frame each way. These lines intersect with each other at four different points in the frame. Each of these points is a strong position at which to place the subject. Placing the horizon on one of the lines can create a powerful composition as well. Many SLR cameras have optional viewfinder screens that are gridded in this manner. These grid screens are often much better for composing than the standard screens, and I add them to all my cameras, as the lines help me to compose pictures and to keep horizons straight.

Python in rainforest, Queensland, Australia. *The main subject of this photograph is in a powerful place within the photograph, in the upper right-hand corner, rather than right in the center. Placing the snake in the center of the photograph would not have created as strong a composition. I used Fujichrome film for its bright rendering of greens in the rainforest, and I used a flash to highlight the snake. Because matrix metering doesn't work in situations like this, I chose to use manual flash, varying the power of the flash to ensure a correct exposure.*

Crab in jellyfish, Monterey, California. *This is one of my favorite photographs. The subject sits in a powerful place within the photograph, in the lower right-hand corner, rather than smack dab in the center. The curve is formed out of the bell of the jellyfish and winds down to where the crab is sitting, in the interior of what looks like a strange sand dune.*

Tree frog, rainforest, Panama. *This photograph has been very successful in the market. It has outperformed all the other shots I took of these frogs. The composition worked well here, as the frog is sitting on a curve formed by the colored underside of a heliconia leaf. This is an example of the importance of knowing your subject. I had traveled to Panama to photograph a famous research station in the middle of the Panama Canal, and I brought along my assistant and friend, Andy Day. Andy is a biologist who is far more experienced in finding and recognizing birds and reptiles than I am. He was able to find this frog by following its call. We moved the frog to a setup of natural leaves and plants in a laboratory, and I photographed it in many different ways. Of course, we returned the frog unharmed back to its original location in the rainforest.*

Frogs book with tree frog photograph used on the cover.

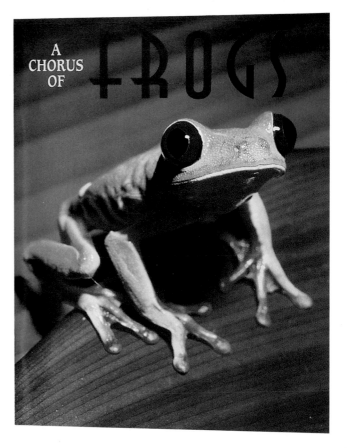

Composing for Publication

All of the above elements of composition can produce stunning photographs. Even if the subject is rare and the negative space is great, however, the photograph will not be published unless it fits the format of the publication for which it is intended. Therefore, you should shoot both verticals and horizontals. Vertical photographs are almost always used for covers, and horizontal photographs fit wall calendars and double-page spreads. Shooting both formats when encountering a worthy subject will ensure that you have the right format available when a photo request comes in. Also, leaving plenty of negative space for art directors to drop in titles and text will help your photograph to be chosen for a cover or double-page spread over other, more crowded photographs.

Would you like to have some published covers in your portfolio? Shoot a vertical composition, and leave lots of even-colored space at the top for a title and some space at the sides for those headlines that many magazines enjoy putting on the cover. The dolphin photograph is a good example of a cover shot. It has space on the top and sides for titles and headlines, and it has been published on the covers of several magazines and books.

63

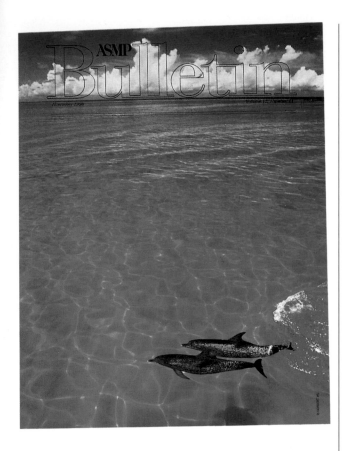

Cover of *ASMP Bulletin. This photograph has been used on the cover of several books and magazines, as well as in advertisements. The composition, with the dolphins in a position of power within the frame, and plenty of negative space at the top make this a natural cover. Reprinted courtesy of the American Society of Media Photographers (ASMP).*

On the other hand, horizontal photographs, when done well, have great potential for use inside magazines as double-page spreads. The photograph of the crab inside the jellyfish would be ideal for a double-page spread. Similarly, one of my stock agency editors jumped on my photograph of a cruise ship in a sunset, immediately imagining its use in a brochure or

Explore cover featuring the juvenile crab in jellyfish. *This photograph was printed as a wraparound cover for the University of California San Diego Extension catalog. The art director flipped the image and made the image warmer in tone, bringing out the pink. Most publishers will assume your permission to manipulate your image in ways like this. I have never complained, and I have even found such usages to be learning experiences. Most people do prefer warm tones such as red, purple, and orange to cool colors such as blue and green. I assume that the art director flipped the image so that the title of the catalog would show in a less cluttered background.*

Cruise ship in sunset, Grand Cayman. *This photograph has become a best-selling image at my stock agency, and it illustrates the principles of shooting for publication. Because this photograph is a horizontal, it lends itself to being featured as a double-page spread. The cruise ship is in a dramatic point in the photograph, in a lower corner. The rest of the photograph is pure negative space. Art directors love using this type of photograph in big ads that run across two pages. They can easily fit type into the negative space, and the subject is generic enough that it can advertise almost anything tropical—cruise ships, vacations, islands, or sunshine.*

double-page advertisement, with copy filling the negative space.

Your Stock Library

Photographs in your stock library must be of high technical quality. Transparencies, 35mm or larger format, are nearly the only practical and accepted medium. Transparencies are used directly to make color separations in the printing process, and the bookkeeping involved in filing and keeping

Sea otter, Monterey, California. *The director of a bookstore once met with me and went through the work that I had prepared for him. His comments were invaluable. It turns out that images of cute animals such as this sea otter sell well, but there are good sea otters and not-so-good ones. The good ones have dry faces, and the fur on their face is white and fluffy, rather than wet and dark. The ideal shot would be of a mother and pup both with dry, white faces. You are trying to get the ultimate sea otter picture, the very epitome of cuteness. A drowned rat is not cute. A sprightly, fluffy, bright-eyed otter is cute. The same thinking applies in photographs of people. The best stock photographs are those in which the photographer has paid attention to the slightest details in the subject's clothing, makeup, and posture.*

track of a photograph is simplified by using transparencies rather than color or black-and-white negatives.

A good loupe and light table are the most important tools of the trade apart from the camera and lenses themselves. Use your loupe and edit ruthlessly, throwing away any image that lacks proper exposure, focus, or sharpness.

Besides the technical quality of the slides, in shooting photographs for stock, be especially aware of composition, nega-tive space, and color. Try to look at a photograph from an art director's point of view. Use the rule of thirds and diagonal lines in your composition to lend power to your photograph. Make use of negative space to isolate your subject and to allow room for copy and titles. Above all, make use of color—color that bleeds off the frame, color that is warm, and color that is separated from the rest of the background.

Taking on a Self-Assignment

This is the hard reality of nature photography: To stand out from the competition, you must spend the time, on the order of weeks or months, to document an animal's behavior or to produce outstanding scenics of a given area. The second reality of nature photography is that magazine assignments are almost nonexistent. Only a select few publications ever assign nature-oriented stories, and the few assignments available are invariably filled by world-famous shoot-ers, who as often as not have proposed the story in the first place. The only solution,

and the best way to get the experience of planning a story as well as getting the photographs, is a self-assignment. By taking on a self-assignment, you will plan your subjects, a budget, a location, the timing, and a story. It takes experience in working toward a goal to know when you are ready to approach the big publishers with your first proposal. By working on self-assignments before your first real assignment, you will be able to assess your abilities and budgets without the pressure of having to produce for a specific deadline or worrying about disappointing an editor.

The photography world, and within that, the world of nature photographers and editors, is a surprisingly small one. Taking the time to gain experience before approaching this small world of editors will prove invaluable when you eventually do propose your first story or are given your first assignment. Believe me, I have done it all. One of my first big jobs ended in disappointment on both sides. I had not had enough experience to do what was expected of me, either technically or in terms of subject matter, and this first client has yet to give me another call. Since that first big failure, I have come to work almost entirely on my own. I plan my own shoots, budget carefully, work with experts in the field, hire assistants, and coordinate my weeks in the field with timetables of when my subjects are usually found. In this way, I have gained enough experience and confidence to approach the big-name publications with my story proposals. The photographs that I have produced along the way have been tremendously successful, generating hundreds of stories and six books on marine life, with several more in the works.

Wolf eel, Monterey, California.

I first learned to dive while going to college near Monterey, California, and after graduation I spent two months there photographing the marine life. Monterey was my backyard. I knew the area well already, had spent a great deal of time there, and was able to rent a house with a garage, as well as persuade a dive buddy to share expenses and to dive every day with me. This was my first real self-assignment, and it lasted for two months. Each day I went through the same routine: load up the boat, choose a site to dive on, make two dives, and wash gear and bring film in. Monterey was close to Kodak's processing lab, and I

was able to get my film back the next day. By reviewing my film each day, I was able to immediately improve my technique and correct mistakes. By going out to the same areas every day, I learned what animals frequented a given location. A wolf eel and his mate were under a particular boulder. In a certain reef, at 80 feet, gopher rockfish would approach and flare their gills aggressively at the camera. Diving in the open ocean would produce shots of giant jellyfish and the communities of fish and crabs that lived within the jellyfish. Sea otters usually made their way into particular coves and kelp beds in the afternoons and evenings.

The photographs that I produced during those two months formed the core of my business for the next four years. Images from Monterey were made into postcards, calendars, numerous magazine articles, and three books. The main point here is that a self-assignment need not involve high budgets or exotic locations. The main ingredients for success are dedication and professionalism. Dedication means that you go out to shoot every day, and that you learn as much about your story or locale as you can. Professionalism means that you plan your photographic project and concentrate on the important parts of the story, and spend your time on meaningful and possible subjects. For example, I would certainly have loved to photograph whales or sharks in Monterey, but pursuing such subjects with the equipment and budget that I had would have been impossible. Instead, I focused on easily obtainable close-ups of marine life, sea otters, and underwater scenics. I could obtain all of these shots with the small boat that I had available to me. Professionalism also means that you pursue your photography full-time,

Diver and giant jellyfish, Monterey, California.

Harbor seal, Monterey, California.

rather than as a hobby. Obtaining good photographs of animal behavior simply can't be done if you have to report to the office from nine to five. You can't make a living as a nature photographer unless you make the decision to pursue the career full-time.

It was twelve years ago that I took on my self-assignment in Monterey. Since then, I have traveled around the world a dozen times and have amassed a collection of 250,000 images in my library. I have had so much experience with still photography that I am confident of my abilities in this area. When an editor calls now with an assignment (something that happens only once every two months or so, still!), I know exactly what questions to ask. For instance, a television producer recently asked me to film harbor seals in Monterey Bay. All of my previous experience in planning shots came into play, as I contacted the various experts in the area, planned diving excursions, and juggled expenses with boat time and assistants' availability. Except for the fact that all expenses were paid, I operated with the same habits and decisions that have been developed through all my self-assignments. In this strange business of nature photography, you become a professional only by going through several self-assignments.

Marketing

There are three basic steps to marketing images. First, you must take the time to develop a library of images, large and extensive enough that you can fill most queries from editors and art directors. This library will take time to build, and it can consist of images from past assignments as well as photographs shot specifically for your library. An alternative strategy is to work on a single topic or photo story at a time. The second step involves making contact with an agency, publication, or client that can use your image. The third step is recordkeeping: agreeing on a fair price for the photographs, sending out an appropriate submission, and invoicing. Whether you sell your work yourself, through a stock agency, or both, these procedures and techniques will apply. The key to all these steps is professionalism. Professionalism means that you will first take the time to build up a library of technically excellent images. Only after building up this library will you offer your work to potential clients. Professionalism means that you have familiarized yourself with your potential clients' businesses and possible uses for your photographs. Professionalism means that you know the going prices for your work and that you can agree with a client on a price quickly and reasonably.

Knowing Your Market

Most sales result from a proposal or submission that you initiate. If you are a beginning photographer, don't expect photo editors to call you. As a photographer interested in selling your work, you must know your market, study your market, and tailor your submissions to that market. The best way to get started in selling your photographs is to look at a local magazine that could use the type of photography that you shoot. Don't start with *National Geographic* magazine— your proposal will likely be rejected. Start with smaller, regional publications, get to know the magazine well, and then make a proposal tailored to that magazine.

If you want to be published in *Natural History* magazine, for example, you should know that the magazine's "Natural Moment" section needs particular types of shots— shots of animal behaviors, preferably seasonally oriented. A look at *Natural History*'s want lists shows that they are always looking for snow shots for wintertime issues, and so on. The stated criterion of "Natural Moments" is for behaviors in the wild—no studio shots. This rule is sometimes overlooked for the truly unique shot that cannot be obtained any other way, however. A photograph by Stephen Dalton, who specializes in capturing high-speed flash shots of ani-

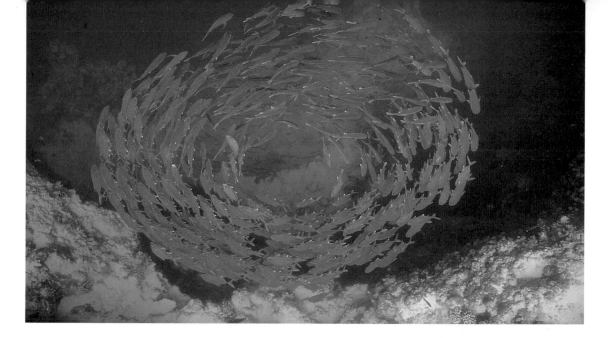

Circling school of bigeye trevally, Borneo.

"Natural Moment" spread of circling jacks. *Used by permission from* Natural History *(2/95) Copyright The American Museum of Natural History, 1995. Text by Judy Rice.*

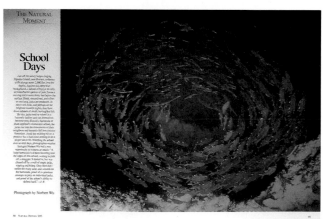

mal movement, involved setting up a pond inside a studio and was published as a "Natural Moment." *Natural History* magazine has recently begun featuring photographic essays, something rarely done in the past. Of course, those portfolios must illustrate natural history themes.

International Wildlife and *National Wildlife* magazines, the two flagship magazines of the National Wildlife Federation, are fine markets for wildlife photographers. Again, knowing the format and editorial preferences of these magazines will help enormously when making your submission. These two magazines have undergone extensive redesigns in the past year, so if you are interested in contributing, it pays to subscribe to these magazines and to keep up with the type of shots that are needed for the covers and inside pages. For example, the front cover now requires a photograph

that will allow a title to be printed across the top left corner. Photographs used on the front cover must therefore have clean negative space in that corner that will not interfere with the title. The inside front cover has gone from a horizontal that bled across two pages to a full-page vertical shot. The back cover has gone from a normal vertical to a vertical that needed to be top-heavy to accommodate a mailing label on the bottom, and then back to a normal vertical.

For any kind of magazine work, it pays to compose your shots with some consideration to their eventual use. If I find a particularly interesting animal or situation, I try to shoot the subject from as many different

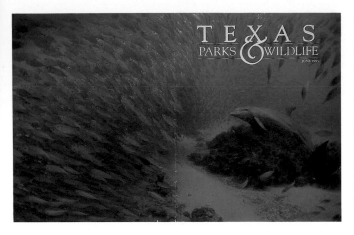

Cover courtesy of *Texas Parks & Wildlife* magazine. *This horizontal photograph of a dolphin within a school of fish appears on the cover of* Texas Parks & Wildlife *magazine. To make the cover of a magazine, you naturally should know whether the magazine uses a wraparound cover (necessitating a horizontal photograph) or a standard vertical format.*

angles as possible, and in both horizontal and vertical orientations.

In past years, if you hoped to get an *Audubon* cover, you had to know that this magazine used a full-wraparound cover, necessitating a horizontal photograph with the subjects in the sides of the frame. In the past year, however, *Audubon* covers have gone to standard vertical formats. You have to keep current with the needs of your clients.

Probably the most common complaint I hear from photo editors is of photographers who approach them with work that is utterly unsuited to their particular publication. These editors dislike having their time wasted by a photographer who obviously has not studied their magazine, calendar line, or greeting card style. For instance, *Audubon* magazine used to be a premier

showcase for scenes of natural beauty: pristine scenics and untouched wildlife. But now, the entire editorial slant of this magazine has changed. *Audubon* now features stories that are almost entirely environmentally oriented. Gone are the gorgeous portfolios of nature photographers. Instead, a recent issue featured articles on Peru's cholera epidemic, the yew tree crisis, the endangered species act, and worldwide trade in marine life. If you approach *Audubon* with a portfolio of your nature studies and wonderful bird shots, you will probably do nothing but irritate the photo editor, who is looking for environmental shots. If, instead, you can offer photographs of endangered animals and habitats, or destruction of habitats, you are in a good position to receive a call from the editor in a few weeks.

It doesn't take much time or money to study and learn a market. Any local library or bookstore will carry enough titles to keep you busy for a long while. In the fall, visit a large bookstore with a good selection of calendar titles. Most calendars have the publisher's name and contact address on the back. Reference books such as *Photographer's Market* also contain numerous listings of calendar, greeting card, and magazine publishers. The *Guilfoyle Report,* a newsletter devoted to information for sellers of nature photography, is another source of information. This valuable but expensive newsletter offers in-depth critiques of various markets, specific publications, and a regular listing of photo want lists from editors.

A Typical Submission

After you've compiled a mailing list of clients, it's time to approach them with a query letter. When I first started out twelve years ago, I began looking for a way to market my underwater photographs. The calendar market was a natural one to target. In the process of contacting the publisher,

Norbert Wu
Wildlife Photographer

Mrs. Smith, Photo Buyer
Calendar Company
Hometown, USA

August 16, 19XX

Dear Mrs. Smith:

I have long admired your company's line of calendars. I am writing to see if you may send me guidelines for submitting to your products. I'd also like to introduce my stock library of wildlife photography.

Our collection of photographs of marine life is one of the most complete in the world, containing the work of the world's finest underwater photographers. We have Bob Cranston's dramatic shark photographs, Peter Howorth's and James Watt's wonderful whale and dolphin photographs, and Peter Parks' unique plankton images. We have it all: photographs from deep-sea vents, from the Arctic to the equator, from coral reefs to kelp forests. We also have photographs from rainforests, Africa, and other habitats.

We can easily create complete calendars based on rainforests, African wildlife, marine mammals, or tropical fishes based on our existing stock. In addition, our library contains photo essays on many of the most beautiful and wild places in the world. The enclosed stock list details these locations, and I will be happy to send you any of these stories. I specialize in showing unique underwater and topside views of travel destinations. For instance, my story on Egypt documents the historic attractions of this area along with superb underwater shots. In November, I will be traveling the length of Kenya, photographing wildlife in the Masai Mara, diving on the coast, and participating in replanting in Amboseli.

I am the author and photographer of six books on marine life, including the tremendously successful children's books *Fish and Faces* and *Beneath the Waves,* and the titles *How to Photograph Underwater* and *Splendors of the Seas.* I know how tight publishing deadlines can be, and I can help solve your problems with my writing and photography.

I look forward to discussing how I might help you in your projects. I have enclosed an SASE for a copy of your guidelines.

Best,
Norbert Wu

producing the calendars, and subsequently mailing them, I learned many things about the publishing business in general.

On the preceding page is an example of a typical letter that I send to calendar clients. (The principles in this letter apply to all sorts of clients.) I print the letter with my laser printer on my letterhead stationery to give a good first impression. I routinely approach clients with laser-printed letters and stock lists, along with pages of duplicates to support my proposals. The investment in printing and office equipment is minimal, and this approach works just fine. The editors who deal with nature photographers are used to mailings and promotion letters that are not glossy, fancy, or elegant. They are used to handwritten captions on slides, badly typewritten letters, and submissions that are obviously produced in home offices. Therefore, any kind of neat presentation, such as a nice letterhead and logo for your stationery, laser-printed letters rather than badly typed or handwritten letters, and neatly presented, typeset, and printed stock lists will make your submission stand out. On the other hand, clients in the advertising and design worlds are used to elegant, fancy, and expensive four-color brochures and other promotional materials. Photographers who are in the advertising and commercial photography worlds spend thousands of dollars a year to promote themselves with color brochures, advertisements in trade magazines, and portfolios.

I try very hard to keep my letters short, one page at most. Photo buyers are inundated with paperwork, and long letters are a sure way to lose their attention. Present your specialty, include some ideas or possibilities to catch their attention, and ask for their guidelines on submissions. Calendar companies have very strict guidelines for submitting. Follow those guidelines! One month they may be looking for dog photographs only. Another month they may be reviewing waterfall photos. I have had entire submissions returned simply because my duplicate slides were not enclosed in Kimacs sleeves, or because the photographs were not captioned exactly according to the guidelines. That hurts, because hours of your time have been wasted.

If you are sending photographs unsolicited, the standard practice in the industry is to enclose a self-addressed, stamped envelope (SASE). If you are requesting guidelines or any kind of response from the editor, you should make it as easy as possible for the editor. A big part of that is an SASE. Be sure that the envelope is large enough to contain your photographs and has sufficient return postage, if that is its purpose.

On the following pages is the stock list that I send out along with this letter. It is not a fancy document. I created this with my word processor, print it out with my laser printer, and keep it to one page of paper, printed on both sides.

After sending your query letter to several publishers, you will receive guidelines for submitting to calendar lines. Your photographs can be included as part of a calendar or as an entire title. Selling single photographs to calendars that use collections of nature photography can be worthwhile. I've found, however, that the competition for the major calendars, such as *Sierra Club* and *Audubon,* is intense. Submitting to these publishers is simply not worth my while. The major calendars have rigid guidelines that you must follow when submitting your work. They also require your originals for review, and because the competition is so intense, you must send your very best originals. These originals can be held for up to a year by these publishers. They are therefore out of your hands for that period of time, unavailable for other projects and unable to generate income for you. Because of the huge vol-

Norbert Wu

**Stock Photographs, Essays, and Cinematography
on the Marine and Rainforest Environments**

Coverage: photography, film, and writing about the rainforest and the marine environment, from the surface to the deep sea. Complete and accurate captions. Specialties include deep-sea life, dolphins, jellyfish, sharks, whales, and animal behavior.

16mm film footage: spotted dolphins of the Bahamas, manta rays at Socorro Island, Galápagos, and dusky sharks attacking bait balls at Socorro Island, harbor seals in Monterey Bay, great white sharks attacking seals at Farallon Islands.

Locations:
Tropical Rainforest: images from weeks of work at the Smithsonian Tropical Research Institute's field station on Barro Colorado Island in Panama. Ecology and rhythms of a rainforest, two- and three-toed sloths including close-ups and mother with young, brilliantly colored red-eyed green tree frogs, fig-eating bats peeling their fruit before eating, howler and spider monkeys, insects galore, examples of mimicry, camouflage, predation, eyespots, chemical defenses, leaf-cutter ants, army ants and bivouacs, rainforest scenics, lineated woodpecker tending a nest, rufous motmot bird, bat faces, basilisk lizard (the "Jesus Christ lizard") running on water, anole and tarantulas attacking and feeding on katydids, iguanas, toucans, coatis, agoutis, and scientists at work.

The Arctic Circle: icebergs, nesting seagulls, glaciers, scenics, and a five-week oceanographic cruise off the open ocean, ice pack, and coasts of Greenland, Iceland, Jan Mayen, Spitsbergen, and Norway. Research on jellyfish, ctenophores, pteropods, and physical oceanography. Iceberg and open-ocean diving, scientists at work, lion's mane jellyfish, comb jellies, digesting krill, parasites stealing food from jellyfish. Spectacular, unique coverage of gelatinous zooplankton—jellyfish and comb jellies.

Australia: wildlife from the deserts, rainforests, and Great Barrier Reef. Manta rays, harlequin tuskfish, platypus, koalas, kangaroos, aerials of the Great Barrier Reef, cassowaries, nocturnal possums, wombats, parrots, lorikeets, and other birds, reptiles, and mammals. Spectacular photographs of kangaroos with joeys in the wild, and koalas with babies. Close-ups of satin bowerbird tending his bower. Great white sharks from South Australia, as well as the deadly blue-ringed octopus, and the cleverly camouflaged leafy sea dragon.

Baja California and the Sea of Cortez: desert, seashore, coral reef, and mountain scenery; spectacular dolphin shots, harems of sea lions, starfish spawning, amberjacks mating, rare photographs of giant 40-lb Humboldt squid, groups of sailfish, marlin, giant 50-foot whale sharks, gray whales, and schools of hammerhead sharks around seamounts. High-tech divers using military rebreathers. Revillagigedo Islands: sperm whales, sharks, and manta rays.

Borneo: Sipadan and Sangalakki Islands, featuring an enormous, concentrated diversity of marine life. Complete essay on the life and death of the green sea turtle, manta rays, coral reef scenes, huge schools of jacks, barracuda, and other marine life.

California: a complete file and essay of the Pacific coast of North America. The entire food chain off the California coast is represented: starting with microscopic plankton, krill, and jellyfish, progressing to anchovies, then aerial views of seabirds, schools of mackerel, pods of dolphins, sea otters, and sea lions, up to sharks and man at the top of the chain. Life in the kelp forest, blue-water diving and wildlife, 30-foot-long jellyfish, bizarre mola molas (ocean sunfish), anemones fighting, nudibranchs mating, kelp forest ecology, sea urchin barrens. Blue sharks attacking and biting diver in steel-mesh shark suit, mako sharks, oil spills, gill nets. Channel Islands Park, anemones brooding young, moray eels with cleaner shrimp, great dolphin shots.

The Caribbean:
Bahamas: spotted dolphins mating, feeding, playing, interacting with man, submersible dives.

Belize: rainforest wildlife, including roaring howler monkeys, jaguars, tapirs. Ambergris Caye, marine sanctuary, huge schools of fish and divers, moray eels greeting divers.

Roatan, Honduras: cleaning stations, great shots of cleaner wrasses and shrimp servicing groupers, close-ups of coral polyps, patterns and colors of marine life, toadfish, coral bleaching, brittle starfish at night, great shots of an octopus hunting and billowing over coral bottom, rainbow over a desert island.

Saba and Dutch Antilles: colorful marine life, cleaning behaviors and symbiosis, green turtles, divers, fish portraits, topside scenics, towns of St. Maarten and French Quarter.

San Blas Islands of Panama: marine life of the coral reefs, working on the Smithsonian Institution's tiny marine station—a small 20-foot island with bamboo

continued on page 76

huts above the water; Kuna Indians.

Grand Cayman Islands: marine life, the scuba industry, divers feeding tamed fish in marine sanctuaries, underwater scenics, coral walls, colorful fish and coral reefs, the Cayman Wall, Stingray City: large 6-foot stingrays swarming around divers, shipwrecks, baby and breeding green turtles.

U.S. and British Virgin Islands: marine life, cave diving, diver with turtle, teaching scuba, above and below, underwater scenics, tunnels and caves, dive guide feeding fish.

Costa Rica and Cocos Island: spectacular shots of hundreds of schooling hammerhead sharks, rainforest scenery and wildlife.

Fiji: symbiosis, coral reef communities, huge schools of barracuda, and idyllic islands, beaches, and palm trees. Green turtle caught by native divers, clownfish laying eggs in anemone, parrotfish sleeping in mucus net, all aspects and behaviors of marine life, stunning colors, spectacular close-ups of marine life.

Florida: alligator, flying squirrels, armadillo, manatees, wading birds, owls attacking mice, raptors, endangered panther. Scenics of cypress swamps, beaches, and the Everglades. Marine life.

Galápagos: unusual endemic fauna: marine iguanas, giant Galápagos tortoises, blue-footed boobies, frigatebirds, and Sally Lightfoot crabs. Underwater seamount coverage: schools of hammerhead sharks and colorful marine life.

Hawaii and the Central Pacific Gyre: coral reefs, brightly colored fishes, and life of the open ocean, diatoms, blue-water diving, gamefish such as wahoo and mahi-mahi, life attracted to floating objects, albatross, oceanographic research and trawling. Stock shots of swimmers surrounded by lemon butterfly fish, islands of Oahu, Kona, and Maui. Humpback whales, pilot whales, false killer whales, beaked whales, spotted and spinner dolphins. French Frigate Shoals: endangered monk seals; tiger sharks attacking fledgling albatross; albatross, terns, and boobies nesting, feeding young, learning to fly.

Kenya: day to day struggles for existence on the African veldt: lions, cheetahs, hyenas, vultures, and jackals, vying for survival among the herds of elephants, buffalo, wildebeest, zebras, and antelope. Also, flamingos, baboons, giraffes, and many other strange creatures from the wilds of Africa.

New Zealand: marine life of both North and South Islands, aerials of bird flocks and islands, the bizarre paper nautilus, gill net fishing, the elephant fish, dolphins, schools of jack, bird colonies, volcanoes, the Maoris and their ceremonies, and other images taken as a photographer aboard Jacques Cousteau's *Calypso.*

White Island, New Zealand: spectacular volcano graphics, clouds of sulfur steam; gannets nesting underneath volcano amidst clouds of sulfur steam, stark lava details and aerial photography.

The Philippines: Batangas Bay marine life: fish and invertebrate life of astonishing color and diversity.

Queen Charlotte Islands: Misty Isles, totem poles of Haida Indians, colorful invertebrate life.

The Red Sea: marine life, Spanish dancers, patterns of marine life, cultural attractions including tombs of King Tut, temples of Dendara, Abu Simbel, Karnak, Luxor, Pyramids, and Sphinx.

The Seychelles Islands: everyone's ideal vacation scenes: palm-lined beaches with pink coral sand and spectacular granite formations; the mysterious Valle de Mai; fabled coco-de-mer nut; over-/underwater shots of desert islands and coral reefs; marine life from the outer Amirantes Islands to the main islands of Mahe, Praslin, and Le Digue; huge schools of red squirrelfish and yellow blue-lined snappers; whale sharks; clownfish; island's endemic species: Seychelles twig insect, tree frog, and leaf frog, the smallest frog in the world.

The Solomon Islands: wild bird trade, colorful marine life, giant clams, life within a crinoid, schools of barracuda and jacks.

Thailand: the mystery and tradition of this beautiful country are captured in topside shots of the people, Buddhist temples, sea-kayaking along coastline riddled with jagged caves, as well as vivid underwater coral reef scenes, featuring brilliant soft corals, deadly lionfish, and many other colorful inhabitants of Thai seas.

Specialties:

Deep-Sea Life: all manner of deep-sea, rare, and unusual fishes.

Jellyfish: all manner of medusae from the huge to the tiny.

Life in a Kelp Forest: a complete file of life off the California coast, representing the entire food chain.

Whales and Dolphins: a complete file, representing several species and spectacular photographs.

Sharks: a complete file of different sharks, from the small, to the deep-sea, to the great man-eaters.

Books Available upon Request:

Splendors of the Sea, Hugh Lauter Levin Associates, 1994. 11.5″ × 11″, hardbound, 200 pages.

How to Photograph Underwater, Stackpole Books, 1994. 7″ × 9″, softbound, 114 pages.

Fish Faces, Henry Holt, 1993. For ages 6 through 8. 10″ × 10″, hardbound, 32 pages.

Beneath the Waves, Chronicle Books, 1992. For ages 8 through 14. 10″ × 10″, hardbound, 40 pages.

ume of submissions that they receive, these large publishers demand that each image be individually captioned and then listed on one of their forms. There is a lot of time involved in such an endeavor, with no guarantee of getting a return for your time.

I decided not to submit to the large publishers anymore after an incident that happened several years ago with Audubon Calendars, which had used my photographs in the past. I sent in a very carefully selected submission of one hundred photographs, all duped and captioned personally. The photographs were returned with four shots marked as possible selects, but with a note saying that since these were dupes, they could not tell about the quality of the originals, and to please send originals next year. What happened to a personal relationship with the picture editor, and why couldn't she have just asked me to send in the originals of the pictures she was interested in? The answer is that the big publishers are inundated with submissions and consequently have no time to communicate with photographers on an individual basis. This sort of relationship, in which I have no personal contact with an editor, is something that I avoid. I work with several smaller calendar publishers now, all of whom accept my duplicates for review and request my originals only when necessary for printing. They require much less time, have less stringent guidelines, and pay just as well as the big guys.

If you have a specialty that may be of interest to a publisher, you may wish to propose a calendar title based on your special collection of photographs. Paper-products publishers, who publish calendars, greeting cards, and posters, are inundated with queries and material from photographers. A professional, clear, and dramatic presentation of your work is therefore absolutely necessary to catch their attention. When you've edited and decided upon your

twenty most dramatic or thematic shots, it's time to contact calendar publishers. As with most photographic projects, a collection of pretty pictures is not enough. Those pretty pictures will be most effective if they're packaged into a proposal, each photograph related to the others visually, through a unifying theme and with captions. Letting the publisher know about the existence of a ready market for the product will also help him decide to invest in the cost of designing, printing, and distributing your calendar. Bear in mind that calendar titles are published two or three years after they are first conceived, so be patient.

When I first started out, I contacted a calendar company with three proposals. The proposal that caught their attention was titled "Life in a Kelp Forest." With it, I had sent a detailed caption sheet describing the natural history of the kelp forest and a suggestion of markets to which this title would be applicable. They eventually decided to publish two calendars featuring my underwater photography in the same year. One was a large, fine-art calendar about the kelp forest, and the other was a smaller, more generic underwater calendar.

Larger publishers may carry as many as eighty different calendar titles for any given year and have as many representative salesmen hawking their wares around the country and internationally. A calendar prospectus is frequently made up and given to those who request it; it's a mockup of the actual calendar on one sheet of paper sized to the calendar specifications, with the cover photograph on one side and sample months and photographs on the other side. These are effective selling tools, and you should request a number of copies for your portfolio. The publisher may also allow you to purchase a number of calendars at substantial discounts (but they never give anything away!), but you must place your order early, before printing begins. Average press

runs may range from fourteen thousand to eighteen thousand copies, with the upper and lower limits being five thousand and forty thousand.

You should duplicate and package your slides into a coherent and visually dramatic submission. I recommend one or two pages of twenty slides for initial contact. Put an emphasis on presenting visually exciting images that relate to a particular theme. In the competitive world of calendar publishing, the more thematic your submission, the better. Generally, photographers are paid a flat fee for the use of single images and on a royalty basis for entire titles. Royalties range anywhere from 6 to 10 percent of total billings, and it is here that some confusion may arise. Publishers offer their products to bookstores at prices discounted anywhere from 25 to 75 percent off retail price, with the average being 50 percent. With a 50 percent discount, a calendar with a list price of $10 would be sold to a bookstore for $5, and the photographer with a royalty of 10 percent of total billings would receive 50 cents per calendar on this particular sale. Another issue that concerns royalty-paid photographers is the subject of returns. Bookstores may elect to return all unsold merchandise for a full refund before a certain deadline, usually March of the calendar year. Your calendar publisher may withhold your royalty payments until all returned publications are in and accounted for.

The publisher can be your best friend, but you will be most satisfied with this mutual arrangement if you keep close tabs on printing deadlines, proof reviews, and publishing quality. Proofs are especially important to see in a timely fashion, as they represent the final chance to proofread the text, check printing quality, and correct gross errors such as upside-down pictures, which happen with distressing frequency. Make sure that you get all relevant dates and call for the proofs on time, as turn-around time may be only a few days if the calendars are being published overseas. Paper thickness and printing screen size for photographic reproduction are good things to check at the beginning.

I recommend proposing stories and sending submissions to editors of magazines and paper-products publishers on your own, after studying their guidelines. Start with smaller publishers and work your way up to the bigger clients and magazines. This way you will learn proper business procedures with smaller, more understanding clients. Once you've worked out a system and can understand what you are marketing, you will be able to deal with the big publishers when they call.

The *Guilfoyle Report* has regular listings of photographs that are needed by natural history clients. This newsletter is an invaluable resource for beginning photographers. I recommend subscribing to this newsletter, reading it carefully, and following the directions listed in the want lists. For example, if the listing for a magazine wants photographs of deer, and you have great photographs of deer, then you should contact the magazine. If the listing states "no calls," then you should *not* call the magazine! Either write or fax the contact person in the listing and let him know about the existence of your photographs. Then wait for him to contact you. More often than not, the photo editor has already found the photographs that he needs. If you call him, you'll only be pestering a very busy person who is already looking for photographs of another subject. Patience is definitely a virtue in this business.

Be Prepared

If you are lucky—and eventually you will be if you are persistent—you'll receive a call from a photo editor who wants to see your photographs. Before this happens, be sure that you have the following systems in place.

1. *Have a filing system and duping system in place.* Photo editors always need your photographs immediately. This is a fact of the publishing and magazine business. Therefore, you need to have a system set up so that you can get your photographs to the editor immediately. You should have a filing system and a slide-duplicating system set up so that you can pull your originals and duplicate them in one or two days. Nearly every city in America has professional E-6 processing labs that can turn your film around in two or three hours. Use these labs to make your duplicates quickly. When you are starting out, professionalism is the key, and every contact that you make is a potential repeat customer who needs to be satisfied.

2. *Have a delivery memo and logging system ready.* My delivery memo states the terms and conditions under which my photographs are submitted. On my delivery memo, I mention the fact that originals of all duplicates are available upon request. This delivery memo is generated by my computer, which keeps track of the photographs that have been sent. The *ASMP Business Bible* contains sample delivery memos and explains many of the terms and conditions here. I highly recommend getting a copy of this valuable publication and creating your own delivery memo, terms, and conditions.

Your delivery memo needs to state the fact that the rights to use your photograph are granted only if you are paid. It needs to state that you are granting only one-time, nonexclusive rights to use your photograph, unless you have agreed on some other arrangement. It needs to set a date by which the photographs must be returned to you. I usually give my clients one month to hold on to my photographs. My clients routinely hold my photographs for much longer than this, and I usually do not bother them with requests to return photographs unless the holding period has been extremely long. I try to make it as easy as possible for my clients to get their job done and to use my photographs.

The next page has an example of a typical delivery memo that I send with all my submissions. On the back of every delivery memo that my office sends out is a list of terms and conditions (see page 81).

3. *Have a system in place to create captions for the slides in your submission.* I use my Macintosh computer and word-processing program to create captions for my slides. Once I create a caption, I store the text in a file on my computer, grouped according to location. This way, the caption files mirror my physical slide library, and I can easily create captions to print on my labels. I use pinfed $3^{1}/_{2}$-by-$^{7}/_{16}$-inch self-adhesive labels from the Stock Solution for captioning my 35mm slides. I use my dot-matrix printer to actually print the captions on the labels.

There are several customized caption creation programs. The Cradoc Captionwriter is one of the most popular programs for the Windows/PC platforms, although I haven't tried it. I use my general word-processing program to perform nearly all the functions in my office.

A caption should assign a number to a photograph, identify the subject with both common and Latin names, describe any natural history notes or behavior, and identify the location. I prefer to identify my locations generally so as not to limit the uses of the photograph. For example, I may identify my photographs of cheetahs as taken in Kenya, but I will not get as specific as labeling the location as the Masai Mara. By describing your locations too specifically, you run the risk of having your photograph tossed out of consideration for a given story. On the other hand, I never misrepresent my photographs. If a photo editor calls me and wants more information about the exact location or nature of a photograph, I help him out as much as I can, regardless of

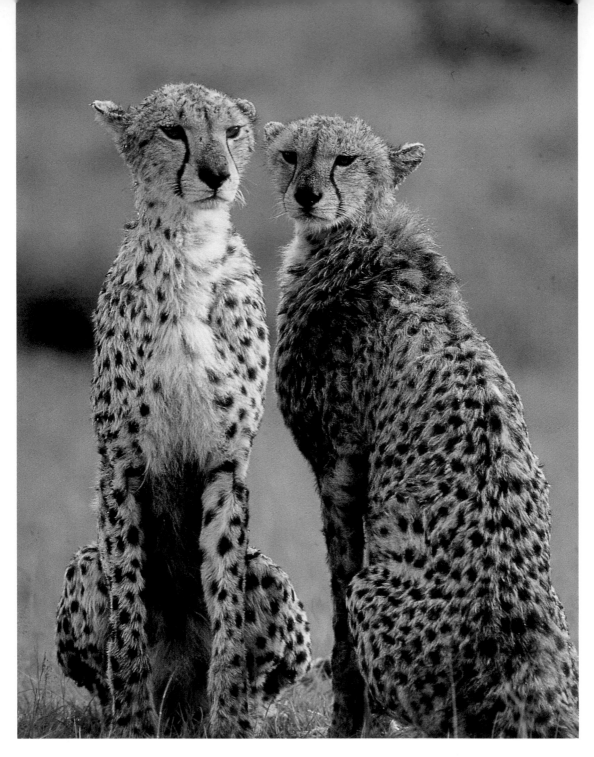

My captioning on this slide reads as follows: "KEN21. Hunting pair of cheetahs in rain. Acinonyx jubatus raineyl. Fastest mammal in the world, 60 mph for 100 yds, not a true cat, Kenya." My name and copyright symbol are stamped on the narrow border of the slide mount.

Norbert Wu
Wildlife Photographer

Stock Picture Delivery # 2367

To: Magazine Publisher 1000 General Street New York, NY 10001	Mrs. Jane Smith Contact Your Purchase Order Number: Date Sent: June 25, 1996

Description of Photographs:

Photos of animals that generate electricity, and animals that can sense electrical fields as requested.

Please note that we represent several photographers and that the credits for photographers other than Norbert Wu must read: ©Photographer's Name / Mo Yung Productions. Photos by Norbert can be credited as: ©Norbert Wu.

35mm Originals: 4
35mm Dupes: 16
70mm Dupes:
Other:

Total Count : 20

Originals of any enclosed duplicates are available upon request. Please note that duplicates are not as sharp or crisp as original transparencies. Please call if you have any questions.

Please return by 7/25/96, or notify. Holding fees apply after due date.

Our agency represents several photographers. Credit line must read: ©1995 Photographer's Name/ Mo Yung Productions. The photographer's name is stated on the photo.

Rights to reproduction of photographs are granted only upon payment of invoice. Rights granted include only one-time, non-exclusive US reproduction rights unless otherwise indicated in writing.
Subject to terms on reverse side pursuant to Article 2, Uniform Commercial Code and the 1976 Copyright Act.
Please note that a standard research fee per submission is charged. This fee will be applied against any fees resulting from the usage of photographs in each submission.

Kindly check count and acknowledge by signing and returning one copy. Count shall be considered accurate and quality deemed satisfactory for reproduction if said copy is not immediately received by return mail with all exceptions duly noted.

Acknowleged and Accepted : _____ Date: _____

A copy of my delivery memo. *My computer database presents information such as the client name and the number of slides that are out with a client in a form that I created within the program. I discuss the terms and clauses of this delivery memo elsewhere in this chapter.*

Terms and Conditions

1) "Photographer" hereafter refers to Norbert Wu. Except where outright purchase is specified, all photographs and rights not expressly granted remain the exclusive property of Photographer without limitation; user (or recipient) acquires only the rights specified. A separate reproduction fee must be negotiated and paid for each subsequent edition, revised edition, foreign or foreign language edition, advertising material, or any other reproduction whatsoever.

2) Submission and use rights granted are specifically based on the condition that user (or recipient) assumes insurer's liability to (1) indemnify Photographer for loss or damage of any photos, and (2) return all photographs prepaid and fully insured, safe, and undamaged. User assumes full liability for its employees, agents, messengers, color separators, and freelance researchers for any loss, damage, or misuse of the photographs. For our mutual protection, photographs must be returned in the following manner: via Federal Express delivery service, registered mail, insured, or United Parcel Service Second Day Air, insured.

3) Reimbursement for loss or damage shall be determined by a photograph's reasonable value, which shall be no less than $1500 per original transparency or $25 per duplicate transparency.

4) Adjacent credit line for photographers must accompany use, or invoiced fee shall be tripled. User will provide copyright protection on any use in the following form: " © 1996 Norbert Wu," or the Photographer's Name and Agency Name stated on the photo, in the form " © 1996 Photographer's Name/Mo Yung Productions."

5) User will indemnify Photographer against all claims and expenses arising out of the use of any photograph(s) unless a model or other release was specified to exist, in writing, by Photographer. Unless so specified no release exists. Photographer's liability for all claims shall not exceed, in any event, the amount paid under this invoice.

6) Time is of the essence for receipt of payment and return of photographs. No rights are granted until payment is made. Full payment required upon receipt of invoice; 2% or $10 per month service charge, whichever is greater, on unpaid balance is applied thereafter. Adjustment of amount or terms must be requested within 10 days of invoice receipt.

7) User shall provide at least three free copies of uses appearing in print and semi-annual statement of sales and subsidiary uses for photographs appearing in books.

8) After 14 days, the following holding fees are charged until return: Five dollars ($5.00) per week per color transparency, print, or negative. Failure to return photographs two weeks after agreed holding period or written demand for return of the photographs shall constitute agreement to a sale of one-time reproduction rights, and an invoice will be rendered for the full quoted price of such rights plus holding fee to date. The holding fee will continue to accrue until full payment of such invoice is made.

9) Submission is for examination only. Photographs may not be reproduced, copied, projected, or used in any way without (a) express written permission on Photographer's invoice stating the rights granted and the terms thereof and (b) payment of said invoice. The reasonable and stipulated fee for any other use shall be three times Photographer's normal fee for such usage.

10) User may not assign or transfer this agreement, or any rights granted hereunder. Holding or use of any photographs constitutes acceptance of above terms, hereby incorporating Article 2 of the Uniform Commercial Code. No waiver is binding unless set forth in writing.

11) Any dispute regarding this invoice, including its validity, interpretation, performance, or breach, shall be arbitrated in Oakland, California, under rules of the American Arbitration Association and the laws of the State of California. Judgment on the arbitration award may be entered in the highest Federal or State Court having jurisdiction. Any dispute involving $1500 or less may be submitted, without arbitration, to any court having jurisdiction thereof. User shall pay all arbitration and court costs, reasonable attorney's fees, plus legal interest on any award or judgment.

whether that information will hurt my photograph's chances for a sale. Lies have a way of coming back to haunt you.

4. *Have a packaging and shipping system set up.* I package all my submissions with the slides captioned either by hand or by computer and inserted into top-loading, archival, polyethylene vis sheets. I recommend the Clear File pages, which can be ordered from B and H Photo or Icon Distribution. I prefer the Archival Classic (format #21) pages, which are top-loading pages for twenty 35mm slides. The Archival Classic pages are made of polyethylene, which is a bit cloudy, but I prefer them to the newer, clearer Archival Plus (format #21B) pages, which are made of polypropylene plastic and are so slippery that they are nearly impossible to hold together in a pile.

I put the slide pages along with a delivery memo and a stock list (I always enclose a stock list with my submissions so that the editors have something to refer to in case they need something later) into a rigid mailer made by Chicago Packaging. These white mailers are made of paperboard, not cardboard, and are rigid enough to protect the package from being bent and folded. I often place the slide pages between two sturdy pieces of cardboard and insert that combination into a 10-by-13-inch rigid mailer.

If you do not already have an account with Federal Express, you should get one immediately. If will cost you nothing. Federal Express has revolutionized the workplace by offering overnight service at relatively inexpensive rates. I use Federal Express to ship perhaps 80 percent of my submissions. Because I am a member of the American Society of Media Photographers (ASMP), I have obtained discounted rates from Federal Express, which makes shipping via Federal Express more economical than couriers such as United Parcel Service (UPS) and only slightly more expensive than U.S. mail. I also have accounts with Airborne Express

and UPS. I usually avoid UPS because I have had problems with the quality of their service. In contrast, I cannot say enough good things about Federal Express. I schedule Federal Express shipments simply by calling their 800 number, pressing a button to enter my account number, and hanging up. The process takes less than one minute, and the courier comes the same day.

I use the U.S. mail for many submissions. For most of my submissions, when I am sending only duplicate slides, I send them via regular first-class mail. This method, however, does not provide tracking of packages. If I need further safety, I will use U.S. certified mail. U.S. certified mail, however, only assigns a number to a package. For the greatest safety, I use U.S. registered mail, which requires signatures on both ends of the delivery and travels under lock and key.

Insuring your photographs for their full value is unworkable (the industry standard is $1500 per original photograph), and most couriers will not accept your packages at those values anyway. Your choice of courier will be dictated by practicality. Usually, my clients give me their Federal Express account numbers to bill the shipment to. In practice, I use Federal Express for the vast majority of my submissions, and I do not insure my duplicate or original slides.

5. *Have a system for the recordkeeping of returned slides and correspondence in place.* When my photographs are returned from clients, I log them into the computer file, in which I keep track of returns. You don't need a computer to do this, however. I started out by simply creating manila folders for my correspondences with my clients. I assigned each client a manila folder. I recorded every submission on the front of the folder, and kept a running total on the folder as well. For any client with slides out, I placed the folder in my "Slides Out" filing cabinet drawer. As soon as a client's folder showed zero slides out, I put

the folder in a different filing cabinet. In this way I knew who had slides of mine. Other photographers simply keep logbooks by their desks in which they write down the client's name and the number of slides that have gone out.

My computer program has simplified this recordkeeping tremendously. I can see at the touch of a button which clients have had slides over ninety days, which clients have originals, and other kinds of data.

6. *Have a system to get photographs back in the files quickly.* When a submission is returned, I quickly refile the returned images. I've worked out a reasonably efficient system over the years. On a shelf over my light table are several stackable plastic letter trays that I use for my returned slides and vis pages. Each tray is labeled with a location that corresponds to one of my filing cabinets, and the trays are arranged in the same way as the filing cabinets. For example, the top, far left plastic tray is labeled "Kenya" and it corresponds to the top drawer of the far left filing cabinet in my library room. When slides are returned, I put them into the trays by location. Once a month I refile all the images into the corresponding filing cabinets.

If a slide has been used in publishing, it will have been removed from its mount and will need to be remounted, cleaned, and

Norbert Wu
Wildlife Photographer

Delivery # 2367

RECEIPTS LOG

Company Name
Magazine Publisher

Delivery	Orig 35	Dupes 35	Dupes 70	Other	Total
6/25/96	4	16			20
Return					
9/25/96	4	12			16

Contact Person:
Mrs. Jane Smith

Submissn. Date:
June 25, 1996

Initial Due Date:
Jul 25, 1996

Total Returns 16 **Originals Out** 0

Slides Still Out 4

Photos of animals that generate electricity, and animals that can sense electrical fields as requested.

Please note that we represent several photographers and that the credits for photographers other than Norbert Wu must read: ©Photographer's Name / Mo Yung Productions. Photos by Norbert can be credited as: ©Norbert Wu.

A copy of my receipts log record. *I use the same program to log in the returns of my photographs. The computer automatically calculates how many slides my client still has.*

recaptioned. I use the Stock Solution's self-sealing transparency mounts to remount my slides. The slides that come back from printers are often full of fingerprints and scratches. For cleaning the slides, I sometimes use PEC-12 (Photographic Emulsion Cleaner). If duplicate slides are dirty, more often than not I will throw them away rather than clean them. Originals have to be treated like the unique treasures that they are. If an original is dirty, I often will not clean it, since contact with the emulsion may damage it further.

7. *Have a system set up for invoicing your clients.* This is the most important step for making a living at what you love, and unfor-

tunately, this is where most photographers fail. You must learn the value of your work, the basics of copyright law, and the basics of pricing and negotiation. Your work as a photographer has a great value, which is given to you by the copyright law (covered in Part Eight). Learning the value of your work and

Stacked slide trays above my light table.

My filing room.

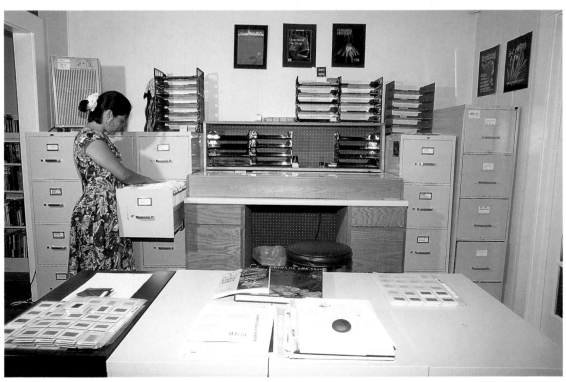

how to negotiate with clients is an ongoing educational process. I am still learning myself, and the changing demands and technology of the market are constantly demanding that I keep up with the intricacies of copyright law and image rights.

If an editor calls you with a request and you put the time and expense into duplicating the submission and sending it out, you should be compensated for your time. I usually charge a research fee of $50 for submitting photographs that have been specifically requested from my office. For very large submissions, I will charge more, up to $300, depending on how much work is involved.

Note that you should charge a research fee *only* if an editor has requested a submission from you. If you are sending a proposal or an unsolicited submission, it is very bad form to charge a research fee. If the client ends up using a photograph from my submission, I will apply the research fee to the usage fee. In other words, if my submission results in a sale, then my research fee is waived. If the client has requested photographs but does not use anything, then my basic costs are covered by the research fee. The research fee is a way to protect myself against frivolous requests. If my client is unwilling to pay a research fee for my time, I will not argue with them. I'd

rather keep the client, but you can be sure that this client goes onto my "bad client" list if they often ask for submissions and don't use my work.

The guidelines given in this chapter apply to any submissions you make, be they for calendars, greeting cards, or magazines. The more complete and thematic your story or set of photographs, the better your chance of eventually selling it. Try to think of packaging your photographs into something that an editor can use easily, with little extra work. Above all, keep at it. Be professional and succinct in dealing with editors, who are very busy people. Don't send anything the editor didn't ask for. If the photo editor has called you for photographs of cheetahs running, don't send photographs of cheetahs mating, feeding, or anything else. The photo editor has a very specific need, and any photographs you send that do not fill that need are of no help. Maintain your professionalism throughout this process.

Guard your time and your precious originals jealously. If a publisher doesn't have enough time to respond to you personally or with respect, be aware that this organization may hold your work for months, take a great deal of your time, and pay you nothing for it.

The Real World

How to Recognize and Help Your Best Clients

To stay in business as a photographer, you have to be fairly savvy. If you're not careful, you could easily find that your valuable original photos are being kept for months and months, with your phone calls and letters asking for their return going unanswered. I will describe several common scenarios in the business of selling photographs. I'll also suggest some tactics that I use to keep working with the people that aren't quite professional, and some techniques that are just common sense.

Good and Bad Clients

A typical conversation with a good client goes like this:

Client: "Do you have any photographs of cheetahs running? We need them right away."

Photographer: "Sure, I have some great shots of cheetahs running. I can send them to you today. Do you want us to send them via U.S. mail or Federal Express?"

Client: "Please send them Federal Express. Here's my account number to bill the shipment to."

Photographer: "Great! You'll get these tomorrow. We do charge a research fee of $50 for submissions that is applied to any usage fees that result from the submission. Is that OK with you? Also, do you want this sent FedEx Priority or Standard?"

Client: "The research fee is fine. Please send the package via FedEx Priority so that it gets here right away."

This is a good client. He does not expect me to pay for his urgent need for photographs. He probably expects to pay a research fee, and he will not argue with it if the amount is fair. I will simply include an invoice for a research fee along with the submission.

Here's a typical scenario with a bad client:

Client: "Do you have any photographs of cheetahs running? We need them right away."

Photographer: "Sure, I have some great shots of cheetahs running. I can send them to you today. Do you want us to send them via U.S. mail or Federal Express?"

Client: "Can you send them Federal Express Priority?"

Photographer: "I can do that. Our office policy is to send submissions out via U.S. mail at our cost. If you want this sent out via Federal Express, then I need an account number to bill the shipment to."

Client: "Oh, we don't have a Federal Express account. Can you just send the submission out and bill us for the cost?"

Photographer: "Well, we don't normally do that, but I'll make an exception in this case. By the way, we do have a research fee of $50 that applies to submissions. That fee is applied to any usage fees that result from the submission. Is that OK with you?"

Client: "Gee, we really don't have a budget for research fees. Can you waive it this time? I've got lots of projects coming up that I want to use you for."

Photographer: "Well, since this is the first time we've worked together, I can waive it this time."

Client: "Great! I'll expect the photographs tomorrow then."

This scenario has happened to me quite a few times. What typically happens is this: The client receives the photographs and decides that he doesn't need them. He returns them with no note, no call, no letter of thanks, a few weeks or months later. In the meantime, you have paid for the shipping costs to rush this submission to him. You have invoiced him for shipping, but he ignores the invoice. After a few months and a few letters asking for payment, you call him to demand payment. The client states that he has no recollection of approving such a charge. He states that you were trying to get a sale and that it was your responsibility to pay for the shipping to get the photos to him. You are in a bad position here. If you argue with the client over such a petty amount, you can forget doing business with him in the future. The only solution to avoid such problems is to set a firm office policy that you and your staff do not deviate from. Do not allow your desire to become published cause you to give away your time, effort, and work cheaply. Don't allow a client to put you in a bad position.

You need to recognize the good clients—those editors and researchers who value your work and efforts. Here's a letter from a photo researcher that struck me as being fair and thoughtful. She had held a few of my photographs, including originals, for nearly a year for a book project. Here's her letter to me:

I am herewith returning thirty 35mm transparencies sent to [us] last October for use in our book series. Although two of the photos had been selected for use in the series, I am afraid the publisher ran into some budget problems in the manufacturing stage and had to cut some of the color section at the last minute. Therefore, none of your photos were used in the series.

I am very sorry about this, Norbert, and quite disappointed. Your photographs are absolutely beautiful. I really feel badly about holding the material for so long and then not even using it, particularly after you were kind enough to work with us on our budget. Although we do not normally pay holding fees, I am enclosing a check for $100, which would have been the usage fee for the two slides we had selected.

I hope that we will have the opportunity to work together in the future, when we have a better budget and a less time-consuming project.

There are a number of points about this letter that merit discussion. First, it is common practice for publishers, especially book and magazine publishers, to hold your material for months on end. Second, it is common practice for publishers to cancel the use of your photographs at the last minute, with no compensation to you, regardless of their previous promises. Third, a usage fee of $100 for two photographs is unprofessionally low. I had sent these photographs to this researcher early in my career, before I had developed a sense of what photographs are worth. Finally, it is unbelievably rare to find a photo researcher who has the time and thoughtfulness to send a personal letter of apology and praise, along with a check to back up her words!

I've developed a number of ways to solve these recurrent problems of a photo library, and to lower my blood pressure.

As a rule, I send only duplicate slides to clients. Some of my best and most lucrative clients routinely hold my work for over a year at a time, and by sending duplicates, I am happy to allow publishers the time they need to put a book together.

I avoid celebrating news of any sales until the check arrives and has actually cleared. I now go so far as to treat all promises of payment with cynicism until my bank statement comes through, assuring me that the check has not bounced. Don't go out and buy that new lens when an editor tells you that he will be using your photo; wait until the issue or book has in fact come out. One day the entire project will be canceled and you will be left holding the bag. It is a simple fact of life that photographers are always the last people to be paid.

The usage fee I am offered for photographs can range anywhere from $100 to thousands of dollars. Photographers hurt themselves if they sell their work for too little. I rarely work with publishers who pay less than $150 per photograph, but I often give a break on price if several photographs are used. Most editors are quite receptive to an honest research fee—for a submission that fills their request, is of high quality, and is reasonable. On the other hand, no one in the business pays holding fees. If you charge a publisher a holding fee, it will certainly be the last business dealing you will ever have with that publisher.

The Flip Side

Here's a letter I wrote to a publisher who called me with a request for pictures of large, rare, hard-to-photograph animals. I discovered that this publisher had used a stock agency for the initial stages of their project, and they were calling me with requests for photographs that the stock

agency couldn't supply. The problem was that they expected to pay the same low price for my rare, hard-to-get photographs as they had paid the agency, who sent them over a hundred easily obtainable photographs. Here's the letter I wrote them, after much thought:

As a photographer who specializes in marine life, I take great care with the documentation and coverage of my stock library. My very best work always remains in my library; my agencies get my second-best material. I've also found that no agency can match the expertise that I have gained from my many years in marine biology. For these reasons, I believe that the practice of going to agencies in the initial stages of a photography project is detrimental to the health and well-being of both of us. The publisher doesn't get the best material that it could get, and specialist photographers like me are left filling those extremely hard-to-get photographic requests at prices that are not worthy of the time it takes to obtain them. This means that my bread-and-butter shots, those shots that are easier to obtain, are not subsidizing the cost of my more difficult photographs. In the long run, this will mean that specialist photographers will not have the money to pursue more difficult subjects. Inevitably the quality of photographs that publishers need to stay in business will deteriorate.

In conclusion, here are some ideas on how to help photo researchers help you. Charge a research fee honestly, but don't pursue a small fee at the expense of losing a client. Ask the right questions, and fill requests with what the publisher needs, which may not be the photographs that you like. Don't send out originals to book projects, because they will be held for too long. Instead, invest in duplicating equipment and send dupes. Value those rare

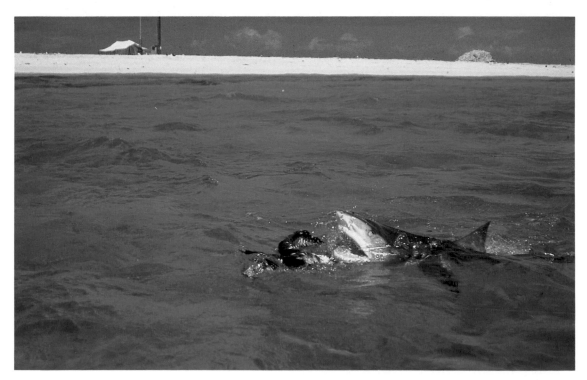

Tiger shark attacking fledgling albatross, French Frigate Shoals, Hawaii. *These shots took enormous expense and preparation to get. Difficult, rare shots such as these should not be lumped together with an easily obtained shot of a flower or a common fish.*

Cover of *Splendors of the Seas*. Published by Hugh Lauter Levin Associates, Inc. Cover design by Lee Riddell.

researchers who have a sense of fairness—if they ask you for a submission, they take care that your efforts are rewarded. On the other hand, dispense with the researchers who don't value photographers, who call upon dozens of photographers for one small photo request, and who repeatedly request photographs but never use them. Value those researchers who call you personally. Give them quality, and value them for the faith and good sense they have in calling you for your work.

Doing a Book

If you are a photographer, chances are that one of your dreams is to do a book. And the book you have in mind is probably one of those glossy, big, thick, expensive portfolios of your best images. A coffee-table book. Chances are, if you seriously pursue the idea of a book, it will turn out much differently from what you may have expected or wanted. I didn't fully comprehend the many decisions, compromises, and ideas that go into a book until working on my fifth and largest book, my first large-format portfolio of images, *Splendors of the Seas*. I learned more about the publishing process in working on this book than any other one.

The Proposal

Possibly the first thing to learn about books is that more than 50,000 new titles are published every year. There are nearly as many publishers as there are books. Books consisting of photographs are a tiny percentage of this number, and nearly all of these titles supposedly lose money. From what I have heard, most titles at a publishing company don't make back the costs of production, and it is only those few books that are very successful that bring in enough money to pay for another round of efforts. So your subject for a book has likely already been done. Your book probably won't break any new ground on the subject itself, but instead will show your subject in a new light. You should not expect to retire on the sales.

The next thing to learn about book publishing is that the people in charge of your book proposal are word-oriented people, with virtually no experience in or knowledge of photography. Your book proposal will be judged almost entirely on the quality of its writing and ideas, not the photographs. Any photographs you submit along with the proposal may be given a brief, cursory glance at best. More likely, however, is that you've sent the photographs along in a form that the editors can't view properly. I've visited major publishing houses that didn't have a single light table or slide projector in the office—so all the transparencies that you send to support your proposal would be ignored. Chances

are that your portfolio box of prints is too big and complicated for editors to look at also. Instead, your two-page book proposal is copied and sent along by interoffice mail to the various people that need to see it, while the photographs remain at the assistant's desk or in the receiving room. Therefore, your written proposal needs to stand out. It needs to capture an editor's attention, because your photographs may not.

I've heard differing views on whether a book dummy helps or hinders the possibility of a proposal being accepted. On one hand, many editors would like to see your idea of how your book will look. Pasting up color photocopies of photographs along with text could give the editor a sense of how wonderful your work really is. On the other hand, giving the editor such a concrete example of your idea might doom your project. If the editor has a slightly different view of how your subject should be represented, he might decide that your book dummy differs too much from his view. I tend to be general in my proposals, letting the editor visualize the book in his mind. I've had too many experiences where a proposal was rejected because it did not fit exactly with the ideas the editor had on the subject. For instance, I once proposed a film on the spotted dolphins of the Bahamas Banks, one of the few places in the world where wild dolphins regularly interact with people. I put together a demo reel showing behaviors and general scenes of dolphins in their environment. The first producer rejected my proposal because it did not contain interviews with scientists. I therefore included interviews with scientists in my written proposal before sending it to a second producer. Guess what? The second producer rejected it, stating that he was looking only for pure natural history films, without people! And I hadn't even changed the demo reel, which showed dolphins only. Don't try to foretell an editor's desires. Propose the book that *you* want to do, but make it general enough that an editor can shape it to his expectations.

Once you've written a proposal, the question arises over whether you can send the proposal to several different publishers at once. As a writer, I feel that simultaneous submissions are the only way to have a proposal eventually accepted. Publishing houses hold submissions routinely for six months to a year. If I had followed the rules that publishers would prefer, my book on the rainforest would still be in the proposal stage when I reached the age of fifty (I'm thirty-five years old now). My rainforest proposal has gone to more than twenty different publishers starting three years ago. One publisher just returned my proposal with a rejection after holding on to it for a good two years—and then only because I notified her that the proposal had been accepted at another house!

By sending the proposal simultaneously to several different publishers, you greatly increase the chances of getting your proposal accepted somewhere within your lifetime. On the other hand, it is your responsibility to notify all editors who are considering the proposal of its status. If an editor has taken the time to champion your proposal, it is a great investment of time on her part. If she has pushed your proposal past the marketing people, the corporate people, and the financial people, and then she writes you a congratulatory letter regarding the acceptance of your book, do you think she will be happy when you inform her that the book was accepted three months ago at another house? Simultaneous submissions are okay. Just let anyone who receives them know that they are being considered elsewhere, and notify everyone who is holding the proposal immediately if it is accepted or seriously considered. And a last note: Don't bug the editor. If you send an editor a proposal, don't call and ask about it. She'll get back to

you in her own time, be it weeks or months. I might call or drop a note once a manuscript has been held past six months.

On the following pages is the proposal that I used for my book *How to Photograph Underwater,* which was published in 1995. A sheet of twenty duplicate slides accompanied this proposal.

The Contract

The first book contract is usually the hardest to land, and it will undoubtedly be one of the more confusing legal documents that you have had to struggle through. I can only recommend some of the wonderful books on this subject, such as Richard Balkin's *Negotiating a Book Contract.* The American Society of Media Photographers (ASMP) has also published a section on book contracts as part of its new *ASMP Business Bible.* I heartily recommend a membership in ASMP, which has helped me time and again through all manner of questions and problems. I have discussed contracts with the directors of ASMP at length, and I have always been surprised at the personal attention given to me, even when I was starting out, an anonymous member.

I do have one word of warning for the photographer comparing his contract with the ASMP recommendations, however. ASMP's contracts heavily favor and protect photographers, as they should. In the real world, however, asking for everything that ASMP's sample contract suggests may be asking for trouble. Early in my career, I once took apart a stock agency's contract word for word, asking that it be changed to better follow ASMP's guidelines. The agency dropped me like a hot potato. I am now much more experienced. I know about how far to push a publisher, what clauses might be easily changed, and which clauses might not be negotiable. That kind of judgment comes only through experience, discussions with colleagues, and a book on negoti-

All of my books that have been published. Jacket of *Beneath the Waves* by Norbert Wu © Norbert Wu, published by Chronicle, San Francisco. The jacket of *Fish Faces* by Norbert Wu published by Henry Holt & Company. Jacket of *A City Under the Sea* reprinted with the permission of Atheneum Books for Young Readers, an imprint of Simon & Shuster Children's Publishing Division from *A City Under the Sea* by Norbert Wu. Copyright © 1996 Norbert Wu.

ating that is as down-to-earth and truthful as Richard Balkin's.

Standard publishing contracts are geared to the writer, not the photographer. You will have to add clauses that protect your photographs from damage and establish their value. Delete any clause that remotely resembles a work-for-hire agreement, which grants all rights, the copyright, or any right other than nonexclusive subsidiary and publishing rights to your writing or your

Secrets of Underwater Photography
A Trade Book Proposal

Description:

In the past two decades, scientists and the general public have taken underwater exploration from a specialized endeavor to an accepted everyday activity. Scuba diving has become an established recreational sport, and scientists have embraced underwater research as an accepted field. Fundamental to this explosion of interest in the underwater world has been a means of recording marine life, research, and other activities underwater.

Diving and snorkeling are activities that people of all ages are taking up. Aquariums such as the Monterey Bay Aquarium, National Aquarium, and St. Louis Aquarium are experiencing growth like never before. Interest in the underwater world and underwater life has never been stronger. The Discovery Channel has found that its most popular programs are about marine life. There are hundreds of diving clubs in the United States and abroad, as well as clubs devoted exclusively to the pursuit of underwater photography. Families on vacation are purchasing the plastic disposable, underwater cameras mass-marketed by Kodak and Fuji. Recreational divers are traveling to the most remote corners of the globe in hopes of attaining spectacular underwater images. They are purchasing underwater photography equipment in astonishing numbers. Sales of new equipment have become a multimillion dollar industry, and include the new autofocus cameras, the tried and true Nikonos amphibious cameras, portable video cameras, and the assorted peripherals such as housings, lights, and strobes.

Several books on underwater photography have been written in the past twenty years. No book, however, has explained the new equipment and techniques such as TTL flash, autofocus, split-field, high-sync speed, or video. This I propose to do. I also propose to explain the techniques of underwater photography by emphasizing subject matter and the making of a particular type of photograph. This approach should make the book simpler to understand than the other books on the market.

Secrets of Underwater Photography will explain professional "secret" techniques and considerations to make people better underwater photographers and get them started on the road to publishing success. The book will start each chapter with the techniques and equipment used in a specific type of underwater photography. Examples of different types of cameras, lenses, and lighting techniques will be illustrated, and the "right tool for the right job" approach is emphasized. The limitations of the underwater environment lead to a limited range of useful equipment and techniques, and a primary objective of the book will be to show the exact lens/camera/lighting combination for a given type of photograph—be it close-ups, fish photography, divers, or scenics. After a discussion of the basics, a "Pro Tip" or "secret" is explained in detail, which expands upon the basic information just presented to produce an advanced effect or photograph.

Also unique to the book will be a discussion of the market for underwater photography. Examples of Wu's published work will be shown and discussed. Marine wildlife photography requires specialized markets, but the market for well-done photographs of models in tropical locations seems to be wide open. Commercial and advertising photographers should benefit from this discussion, as well as the beginning underwater photographer who is curious about the possibilities of making a living from his diving.

The book will consist of sixty to eighty photographs and will be about two hundred pages long. The basic equipment used in underwater photography will be described, and the techniques of using these different pieces of equipment will be discussed and illustrated with photographs. A few large, dramatic photographs will be preferred to many small photographs. Still cameras, video cameras, and motion picture systems will all be discussed in detail.

This book would not be the usual coffee-table or how-to book. It will be targeted to the recreational diving audience, but would also appeal to serious amateur photographers and snorkelers. Thousands of potential readers are members of scientific and commercial diving organizations in industry, universities, and institutions such as the Smithsonian and the American Association of Underwater Scientists (AAUS). Special editions of the book could be sold through diving and photographic equipment manufacturers, as well as through the recreational diving marketplace.

Outline:

The book will start with a discussion of the behavior of light underwater and how these differences affect camera and lighting techniques for underwater photography. Types of underwater photography systems will be evaluated and specific recommendations will be made. The use of strobe, filters, and available light will be covered after an understanding of refraction, color loss, and scattering is developed.

I. Introduction
II. What happens to light underwater
 A. Color absorption: Reds and yellows are absorbed by water by 10 feet, which necessitates the use of strobes to bring back red and yellow colors at any depth past 10 feet. This also limits the strobe-to-subject distance to 6 feet or so.
 B. Refraction: Lenses must be specially designed for use underwater; measurements of focus distance are thrown off. Dome ports must be used on housings, and the image at infinity is actually focused a few inches away from the dome port.
 C. Scatter: Images are unsharp past 20 feet or so away.
 D. Backscatter: Strobe position is crucially important in both close-up and wide-angle photography.
III. Photographic fundamentals
 A. Exposure:
 Shutter speed: usually at rated sync speed
 Film speed
 Aperture
 B. Depth of field and the concept of hyperfocal distance
 C. Lighting: Available light versus strobe, types of strobe, how TTL can be fooled, how to fool the meter to work for you in difficult lighting situations, use of filters with and without strobes. Lighting techniques: one very wide-angle strobe, two smaller macro strobes. Limited to 6 feet from subject, color loss, refraction, scatter. The concept of balancing strobe light.
 D. Films: Kodachrome versus Fujichrome, slide versus print film. Large-format systems.
 E. Lenses and focal lengths: There is a specific lens/camera/strobe combination for each type of shot. The limitations of the underwater environment lead to a limited range of useful equipment and techniques, and a primary objective of the book will be to show the exact lens/camera/lighting combination for a given type of photograph, be it close-ups, fish photography, divers, or scenics.
 • Close-ups (Nikonos 28mm and 35mm lenses with extension tubes and close-up kit)
 • Available lights/silhouettes (Nikonos 35mm, 28mm, 20mm, 15mm lenses)
 • Wide-angle (Nikonos 20mm lens)
 • Ultra-wide-angle (Nikonos 15mm lens)
 • Medium wide-angle (Nikonos 28mm and 35mm lenses)
 • Housed cameras with 50mm and 100mm macro lenses
 • Housed cameras with 28mm, 24mm, 20mm, and fisheye lenses

IV. What makes a good photo
 Introduction to composition
 Introduction to expectations vs. equipment
V. Types of photographs
 Available light
 Silhouettes
 Macro
 Marine wildlife portraits
 Wide-angle
 Divers
 CFWA
 Behavior
VI. Camera maintenance
 Routine maintenance
 Emergency rinsing
VII. Getting published
 What sells
 Duplicating slides and making a submission
VIII. Advanced topics
 Shooting into aquariums, making dead fish appear lifelike
 Processing E6 film in the outback
 Designing battery rechargers for 12-volt car batteries
 Nicad, alkaline, lithium, and silver oxide batteries
IX. Motion picture cameras and video
 Video cameras: formats, controls, editing, broadcast quality

Biographical Sketch:

Norbert Wu's writing, photography, and cinematography of marine life have appeared in numerous books, films, and magazines, including *National Geographic, Audubon, Harper's, International Wildlife, Le Figaro, Natural History, New York Times Magazine, Omni, Outside, Sierra,* and *Smithsonian.* He has worked as still photographer for Jacques Cousteau's *Calypso* in New Zealand; as research diver for the Smithsonian Tropical Research Institute; as cinematographer for the PBS *Nature* productions *Seasons in the Sea* and *Shadows in a Desert Sea;* and as underwater photographer for expeditions ranging from the freezing waters of the Arctic to the equatorial Pacific, for the National Geographic Society, Scripps Institution of Oceanography, and other institutions. He is the author and photographer of three adult and children's books: *Life in the Oceans* for Little, Brown, *Beneath the Waves* for Chronicle Books, and *Fish Faces* for Henry Holt. Profiles on Mr. Wu and his work have appeared in KGO-TV's *Profiles of Excellence, Darkroom and Creative Camera Techniques, Nature Photographer,* British *Photography, PhotoPro,* and *Photo District News.* He serves as associate editor of *Nature Photographer* magazine. His extensive photographic library of marine and topside wildlife includes complete essays on deep-sea life, tropical rainforest life, sharks, and open-ocean life.

All of these photographs were considered for the cover of *Splendors of the Seas. In the end, the most colorful photograph was chosen.*

Green sea turtle hatchling makes it way to the sea, Borneo.

Queen angelfish, Roatan, Honduras.

Harlequin tuskfish, Great Barrier Reef, Australia.

manuscript is rejected. Also include a clause that allows you to purchase as many copies as you wish at a discount greater than the publisher's standard discounts. Seventy-five percent off list price is a good number to aim for, although a difficult one to get.

Royalties and Advances

The advance is the amount that the publisher pays out of your predicted future royalty earnings. Most agents suggest that you should go for the biggest advance you can get, because few books make a lot of royalties from sales past the advance amount. The conventional wisdom that a large-format photographic book cannot earn enough money to justify paying a large advance is not true in all cases. The publishing business is a huge industry, and each player has a different approach.

In the case of my newest large-format book, I approached numerous publishers, all of which rejected my proposal. Then I found one small publisher, which specialized in producing books for the dive industry, that was interested. This publisher offered an advance of a couple thousand dollars and a royalty starting at a low 10 percent of invoice price (invoice price can range from 25 to 60 percent of a book's retail price). Although I was tempted, I declined, reasoning that the time I would spend doing

photography. Include a clause that ensures that your copyright to the photographs and writing will be assigned, registered, and credited. Give the publisher only nonexclusive rights to your work, and be sure that you retain the right to sell single photographs to other markets such as calendars, magazines, and noncompeting books. Make sure that you understand subsidiary rights—the right to sell excerpts of the book to magazines, electronic publishers, and other venues—and that you will be treated fairly if the publisher sells these rights. Make sure that your name will be properly credited on the book cover. Protect your time and efforts by including a clause that allows you to keep the advance in case the

the book would not justify a quality job at those low rates. A few months later another publisher called. This publisher specialized in large-format books to the general trade— a far larger audience than the specialized dive market. The advance and royalty rate were far more generous, and I eventually went with this publisher. I could not have made a better decision. Different publishers have different markets and budgets, and it pays to reject offers that don't make financial sense to you, no matter how many rejections you have received.

Peacock flounder, British Virgin Islands.

Lionfish yawning, Borneo.

Coral grouper, Borneo.

Generally, advances for books involving photographs, whether they are children's, how-to, or smaller coffee-table books, should fall in a range between $5000 and $12,000. Advances for larger coffee-table books should fall between $10,000 and $25,000. I have accepted offers at the bottom and the top of these ranges. The writing is included in these figures. One thing to keep in mind is that books are almost always produced with stock photographs, those photographs that are already in the files. I have rarely heard of a book publisher advancing money to a photographer to complete a book project.

Royalty rates fall in a more predictable range. Invoice price, or dealer price, refers to the actual price that the publisher gets for selling the book to a dealer, which is usually around 50 percent of the list price. So a royalty rate of 10 percent of invoice price is

Four-eyed butterfly fish, Saba, Caribbean.

actually less than 6 percent of list. In general, the lowest royalty rate you should accept is 10 percent of the invoice price. A good royalty rate would be 10 percent of list. (If a publisher is offering a low royalty rate, he will couch the terms in invoice price rather than quoting a low percentage of list price.) Escalating rates, which depend on how well the book sells, are good to ask for.

Throughout the negotiation process, you should express your pleasure to the editor that he likes your work enough to offer a contract. Even if contract negotiations become stressful, remember that he is your friend, because it was his efforts that pushed your proposal past the many other ones at that house.

The Final Product

Although I had worked on four books before my first large-format book, I never fully comprehended the many decisions and compromises that had to be made in the production of a book. I've also learned, the hard way, that a writer and photographer is not an expert in layout or marketing. How a book is designed depends a great deal on who the intended audience is. In my recent book, the biggest controversy arose over the selection of an appropriate photograph for the cover. As a specialist in underwater photography, I wanted a photograph that showed design, that was a work of art in itself, and that depicted an unusual subject. The book designer had her favorites, and the publisher had his choices.

After weeks of agonizing over different covers, the publisher decided on a photograph that neither I nor the designer liked much. I thought that the subject of the photograph, a colorful coral grouper, was too common. The designer didn't like the busy background of yellow corals. The publisher chose the photograph after showing it to numerous people who would be potential customers. Those people responded to the colors and warm tones of the photograph. I bowed to the publisher's decision, feeling that he would be the best judge of which photograph would best sell the book. He was probably right, as a large calendar publisher later chose the same photograph for a cover, without knowing about the photograph's history.

If you're a photographer, you likely will feel that a book that is a portfolio of your images should be presented as a work of art, with few words and a layout that sets your photographs to great advantage. Unfortunately that may not sell well. The publisher will want to include text, since the text will determine the selection of the book for book clubs, libraries, and other markets. After tearing your hair out over thirty thousand words of text for the book, you will run into the problems of the designer, who needs to fit your text and photographs within the format of the book. The text will be cut, shortened, edited, and deleted. The photographs will be cropped, cut, bled, and shrunk. Your belief in the artistic integrity of your work will be challenged by the designer's need to fit a vertical photograph into a horizontal space in the layout. Your artistic sensibilities will be hurt. You will probably argue with the designer and the editor. If you come through this process reasonably happy, consider your job well done. If the final product delights anyone besides your mother, consider the book a success. If it sells well, as it probably will if you've had profound reservations about the competence of the designer and the publisher, then feel free to take all the credit. No one will know.

Pricing and Negotiation

The Value of Copyright

Before I get into pricing and negotiation, I should discuss the entire foundation of my business—copyright. The United States Copyright Act of 1977 is probably the most important law ever enacted for photographers and other creative people. It grants copyright to the creator of a work, rather than to the organization or individual who may have assigned, commissioned, or paid him to create the work. You own the copyright to your photographs the instant you click the shutter release of your camera. As a photographer, you can give away or sell the copyright to that photograph (a bad idea), or you can learn how to license specific, limited rights to your photographs, thereby protecting your copyright (a good, lucrative, and wise idea). The only way someone else can own the copyright to the photographs you take is if you are working for him as an employee, if your work for him under a "work-for-hire" agreement, or if you grant him the copyright for money or other considerations.

Work-for-Hire

Work-for-hire is an important concept that is easily explained by actual contracts. Here's a typical work-for-hire agreement, drawn from the writing part of the contract of my first children's book: "The WRITER and PUBLISHER agree that the WORK shall be a work made for hire within the meaning of the Copyright Law of the United States, and the copyright and all rights in and to the WORK shall be owned by the PUBLISHER, and the WORK shall be copyrighted in the name of the PUBLISHER."

Contrast this with the photography part of the contract for the same book: "The PHOTOGRAPHER shall retain copyright of all of the individual photographs used in the WORK, and PUBLISHER will arrange for notice of such copyright ownership to appear in the WORK."

Because this was my first book, and because I was not known for my writing at the time, I accepted the publisher's work-for-hire contract for the writing. Fortunately, this publisher had a more reasonable contract for photographers. Since I signed this contract, I can no longer sell any of my writing in the book. The publisher, on the other hand, is free to sell and resell my writing for as long as the copyright remains with him.

Obviously, it is to your advantage not to sign a work-for-hire agreement. I treat each trip, each image, as my retirement fund. I avoid work-for-hire agreements because I would lose the ability to continue making money on my best-selling images. It's been my experience that the more an image sells, the more it is going to sell. The more people

see a fine stock image, the more people want to use such an image. Avoid work-for-hire agreements unless the financial return or exposure is worth losing ownership of your work. I very rarely see work-for-hire agreements from magazines, but occasionally a magazine will send me one for an assignment or text-photo package pulled from my stock files. If the magazine is reputable, and if it values its relationship with contributors, it will delete the work-for-hire clause with a phone call from you. A major publishing house in Los Angeles uses a particularly disreputable business practice. It pays with a check that has a work-for-hire agreement stamped on the back. By signing and cashing the check, you lose copyright to your photographs or writing, or both. Such a publication is not amenable to requests by individuals to void the work-for-hire agreement. Since this magazine doesn't pay well anyway, I just don't do any work for them anymore.

Standard One-Time, Nonexclusive Usages

Because I own the copyrights to my photographs, I am able to sell and resell the rights to use those photographs repeatedly. For instance, the photograph of the deep-sea anglerfish has been used on the cover of *Time* magazine, the cover of *GEO* magazine, on the cover of a children's book on deep-sea life, within numerous books and magazines, and as an advertisement for pharmaceutical products. I am able to charge a usage fee for each use of this photograph because I own the copyright to the photograph, and because I only grant one-time, nonexclusive rights each time I license the use of that photograph. Because the phrase "sell your photograph" is ambiguous, I'll define the phrase here as licensing the rights of your photograph for a one-time nonexclusive use.

In both my invoices and delivery memos, I include the following clause: "Rights sold: one-time, nonexclusive rights unless otherwise indicated."

I've included two sample invoices that give different usage rights to a client. The first one is a typical textbook sale, where the client has not asked for any additional rights other than being able to use my photograph. Note that most magazines reserve the right to use any photographs used in one issue to advertise their magazine. This is fairly standard in the industry. It usually means that your photograph is used only as part of a layout that includes the other design elements—the text and headlines—as well. For instance, my photograph on the *Time* magazine cover can be used to advertise *Time* magazine subscriptions in a card insert for the magazine, as long as that cover is used exactly as it was first published. Time, Inc., cannot use my photograph separately for any other usages, however, unless they negotiate a fee for those additional usages. They cannot publish the photograph in a calendar or use it in any other magazine. They cannot use the photograph in any electronic products, such as World Wide Web pages or electronic versions of the magazine.

The second invoice gives greater rights to a client. In this case, the client is a calendar company. Calendar companies typically and reasonably demand exclusive calendar rights for the year in which the photograph appears in their calendar. Obviously, they do not want the same photograph, or a similar one, to appear on someone else's calendar for the same year. One calendar company that I work with now demands five-year exclusive calendar rights—that is, they will not accept any photographs that have been used in calendars up to five years before their calendar title. I think that five years is asking too much. To accommodate this publisher, I must now check every image I send them for previous usages. The recordkeeping involved in such endeavors can be monumental. As a successful pho-

TIME
FOR KIDS

MYSTERIES OF THE DEEP SEA

Scientists are using new high-tech gear to explore the strange and silent world under the sea

Anglerfish

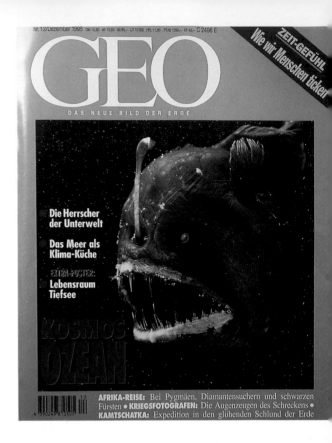

GEO
DAS NEUE BILD DER ERDE

Die Herrscher der Unterwelt

Das Meer als Klima-Küche

EXTRA-POSTER:
Lebensraum Tiefsee

KOSMOS OZEAN

AFRIKA-REISE: Bei Pygmäen, Diamantensuchern und schwarzen Fürsten • KRIEGSFOTOGRAFEN: Die Augenzeugen des Schreckens • KAMTSCHATKA: Expedition in den glühenden Schlund der Erde

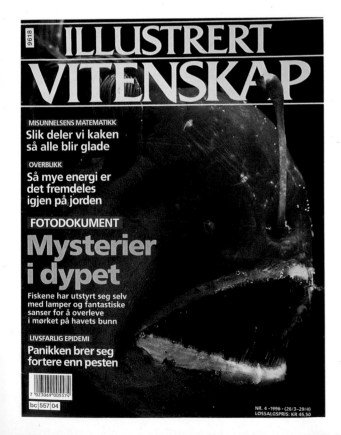

ILLUSTRERT VITENSKAP

MISUNNELSENS MATEMATIKK
Slik deler vi kaken så alle blir glade

OVERBLIKK
Så mye energi er det fremdeles igjen på jorden

FOTODOKUMENT
Mysterier i dypet

Fiskene har utstyrt seg selv med lamper og fantastiske sanser for å overleve i mørket på havets bunn

LIVSFARLIG EPIDEMI
Panikken brer seg fortere enn pesten

NR. 4 •1996 • (26/3–29/4)
LOSSALGSPRIS: KR 45.50

TIME

Mysteries of The Deep

Scientists are set to conquer the last frontier: the ocean floor

Anglerfish

Four different usages of the deep-sea anglerfish photograph. *Cover of* Illustrert Vitenskap *Illustreret Videnskab/Bonniers Specialmagasiner. Cover of* German GEO *courtesy of* German GEO magazine. *Cover of* Time for Kids *courtesy* Time for Kids. *Cover of* Time Magazine © 1995 Time, Inc.

tographer, you will have to decide what you wish to spend your time on. If you begin spending too much time trying to meet a client's demands, or if you give away your rights too easily, you will find that your business is less successful.

Note the clauses at the bottom of each of my invoices. I state that the rights granted for the use of the photographs are only one-time, U.S. rights for one-time use in a single issue or edition in printed version only. If a publisher of a book wants to print a second edition, he will have to renegotiate a fee for the reuse of my photograph (reuse fees are typically 25 percent of the original fee). I state that "no electronic versions, whether identical to the print version or not, are licensed hereby." The world of electronic publishing is a new one that demands care.

Electronic Rights

The new frontier of electronic publishing has publishers pushing for more rights from content providers. Publishers recognize that the electronic marketplace is a new, developing system—and perhaps the most important outlet for publishing in the future. As such, most publishers are inserting electronic rights clauses into contracts, and unknowledgeable photographers and writers may naively sign contracts that assign all electronic rights to them.

Here's a typical example from a magazine that had assigned me a story. In typical magazine assignments, I shoot a great deal of film and give one-time, first-time maga-

Jeweled top snails on kelp, Monterey, California. *This photograph has appeared on a greeting card, on the cover of a magazine, in a calendar, and in several coffee-table books. The key to being able to sell this image repeatedly is licensing specific, nonexclusive, one-time rights.*

Norbert Wu
Wildlife Photographer

INVOICE # 1492

To: Textbook Publisher
1000 General Street
New York, NY 10001

Mrs. Jane Smith
Contact

Your Purchase Order Number: G79744

Date of this Invoice: June 25, 1996

Service/Material Description	Amount
One-time, non-exclusive North American, English language rights to nine photos for use in Earth Biology, print run limited to 40,000. Re-use in subsequent editions must be re-negotiated.	
7 photos @ 1/4 page size, $200 each	$1,400.00
2 photos @ 1/4 page size, re-used in Table of Contents, 25% of regular rate, $50 each	$100.00
1 full page chapter opener	$375.00
1 @ full page unit opener	$375.00
10% discount for volume usage	-$225.00

The following applies except as otherwise specifically provided herein: All photographs remain the property of the Photographer, and all rights therein are reserved to Photographer. Any additional uses require the prior written agreement of Photographer on terms to be negotiated. Any grant of rights is limited to one(1) year from the date hereof for the territory of the United States. The grant of the license stated above is conditioned upon (1) an appropriate credit line and (2) payment of this invoice in a timely fashion. Rights granted: one-time, US rights for one-time use in a single issue or edition in printed version only. No electronic versions, whether identical to the print version or not, are licensed hereby.

Subtotal	$2,025.00
Waive Tax	No
Tax rate	8.25 %
Sales tax	$0.00
Total due	$2,025.00

Due and payable upon receipt. A late charge of 2% or $10 per month, whichever is greater, will be applied to past due accounts.

Please note that our agency represents other photographers. Credit line must read: ©1995 Photographer's Name/Mo Yung Productions. The photographer's name is stated on the photo.

Example of a typical invoice for textbook usage. *Note the very specific, limited one-time rights I have given to this textbook publisher.*

Norbert Wu
Wildlife Photographer

INVOICE # 1491

To: Calendar Publisher
1000 General Street
New York, NY 10001

Mrs. Jane Smith
Contact

Your Purchase Order Number: 41222

Date of this Invoice: June 25, 1996

Service/Material Description	Amount
one-time, one-year exclusive 1998 calendar rights for the following photographs:	
anemonefish, Solomon Islands	$300.00
Sponge spider crab Macrocoeloma trispinosum on sea fan; covered with sponges for camouflage; Roatan; Caribbean	$300.00

The following applies except as otherwise specifically provided herein: All photographs remain the property of the Photographer, and all rights therein are reserved to Photographer. Any additional uses require the prior written agreement of Photographer on terms to be negotiated. Any grant of rights is limited to one(1) year from the date hereof for the territory of the United States. The grant of the license stated above is conditioned upon (1) an appropriate credit line and (2) payment of this invoice in a timely fashion. Rights granted: one-time, US rights for one-time use in a single issue or edition in printed version only. No electronic versions, whether identical to the print version or not, are licensed hereby.

Subtotal	$600.00
Waive Tax	No
Tax rate	8.25 %
Sales tax	$0.00
Total due	$600.00

Due and payable upon receipt. A late charge of 2% or $10 per month, whichever is greater, will be applied to past due accounts.
Please note that our agency represents other photographers. Credit line must read: ©1995 Photographer's Name/Mo Yung Productions. The photographer's name is stated on the photo.

Example of a typical invoice with calendar rights given. *Note the limited exclusive rights I have granted to this calendar publisher. Most calendar publishers require exclusive calendar rights to a photograph for the year of publication, which is entirely fair. Some calendar publishers are now requiring that the photograph not appear in any other calendars for five years before or after publication, which is quite unfair.*

zine rights to the pictures for the magazine. Once the story has run, I am free to use the photographs for whatever purpose I want. I generally do not allow the story to run in competing magazines, which is a courtesy and a sign of professionalism. I can sell and resell the rights to those photographs, however, whether I have taken those photographs on assignment or have paid all expenses to take those photographs myself.

In this case, the magazine gave me a very reasonable fee for my time on this story. In their contract, however, the following clause was buried at the bottom: "Internet Usage Fee: *Generic Photo Magazine* will pay $100 for unlimited on-line usage of the images." This is an open-ended clause that is unreasonable. It shows that the publisher is trying to get all electronic rights to the images for a ridiculously low fee. If I wasn't familiar with this sort of electronic rights grab, I may simply have signed these rights away without giving this further thought. Fortunately, however, I have kept up with electronic rights issues through my membership in organizations such as ASMP and the Author's Guild. I wrote the art director back: "Thanks for the contract. It is acceptable to me except for the Internet Usage Fee clause. I am very sorry, but I simply cannot grant unlimited usage of my photographs on-line. Our office policy is to never grant unlimited usage in any media. Would it be possible to simply cross this clause out, and to negotiate terms if and when *Generic Photo Magazine* needs on-line usage? I'm not opposed to on-line usage, but to unlimited usage. Any other solution to this problem that you might have would be fine." The art director called me back, we both commiserated on the state of the business, and I negotiated a more reasonable electronic rights usage. Since the magazine was giving me a reasonable fee for the assignment, I granted Internet use of my images for one year for $100 per image. That is low.

Generally, electronic rights are priced at 25 to 50 percent of print rights, just like any other subsidiary right. Subsidiary rights are any usages beyond the initial usage. For instance, if a magazine pays $4000 to use several of your images in one issue, a standard subsidiary fee would be $1000 to use those images in another issue. Electronic rights are a subsidiary right, just like the reuse of a photograph on a book's table of contents page. You must, however, be careful to put a time limit or some other limitation on electronic rights or on-line usages.

Pricing and Negotiation Strategies

One of the first rules I learned about pricing my work was this: You win if the other party names his price first. By having the other party name his price, you get an idea of his general range, and you lower the risk of underpricing your work. It's almost impossible to raise your price once you have named it. The following has been attributed to a well-known authority on pricing and negotiation: "When you quote an initial price over the phone, you want to hear the client fall out of his chair. You can always come down or bring things within his budget. But if the first thing he says is 'That's great!' then you know you've seriously underpriced. It's almost impossible to raise your fee from there."

The second thing I learned was that a good negotiation leaves both parties satisfied. I am in business for the long term, and so I try whenever possible to come to a price or an agreement that is fair and reasonable to both of us. By doing this, I've developed a list of repeat clients who come to me anytime they have a need of my specialty in underwater photography or rainforest wildlife.

The best strategy on pricing I have ever heard came from a fellow underwater photographer. If the client gives you a price, agree with him and send out an invoice for

that amount. If the client asks you for a price, name a high sum that you would be quite surprised at getting. If he agrees right away, send an invoice and be happy to get it. If he instead exclaims, "Oh, we couldn't possibly pay more than $1200," then agree that $1200 would be fine, and send an invoice.

The key here is getting over the negotiation stage as quickly as possible. Both of you have other things to do, and both of you probably aren't comfortable haggling over prices. The other key is in knowing what reasonable rates are. A few books such as Jim Pickerell's *Negotiating Stock Photo Prices* give standard fees for different usages based on the size of the published image, circulation of the publication, and other factors. I keep a copy of these standard price sheets near the phone, and I refer to them constantly when negotiating with clients over fees for images that they have already selected. Contrary to what many books recommend, however, I do not haggle a great deal. If a client names a price, unless that price is laughably low, I will accept it. Being known as an easy person to deal with will bring in more business in the long run. Many photographers have different views on this matter, however, and many of them are more successful than I am. What each person in such an arrangement should get is a feeling of a fair and reasonable deal.

I've been paid anywhere from a low of $50 (when I didn't know what I was doing) to a high of $14,000 (when I really knew what I was doing) for a photograph or series of related photographs. The lowest prices and the most quibbling of clients have been the digital media entrepreneurs, who typically want to put together a slide presentation within a multimedia disk. Their prices are typically very low, and they pay months after publication, if at all. I used to avoid them at all costs, but as the technology has evolved, so have the business practices and fees. Also avoid the book publisher who

wants to see a wide selection of photographs complete with Latin names for a guidebook. I have spent a great deal of time captioning and identifying species exactly for such projects, only to be told that the project was called off or that none of my photographs were to be used. It almost seems that the less work you need to do captioning a submission with Latin names and so forth, the more profitable the sale will be. This makes sense, since a great stock photograph, which arouses an emotion or is easily identifiable, needs no caption and will demand a higher usage fee than the more ordinary documentary photograph of a specimen.

Each photographer has his own way of doing business, and I am sure to catch a lot of heat from photography organizations that espouse an entirely different way of doing business. Take all of my numbers and advice with a grain of salt. Each client has differing expectations and experience in dealing with photographers. Each party should get the feeling of a fair and reasonable deal. Most magazines pay a standard fee that is published and available for the asking. Some clients have fixed prices, some pay whatever you want, within reason, and some always try to grab as many rights as they possibly can. I find most clients to fall within a range, however. The medium-sized magazines and publishing houses are very familiar with photographers' issues and concerns, and they know that they are licensing one-time, nonexclusive usages.

I receive prices comparable to what books such as Jim Pickerell's recommend from about 50 percent of my clients. On the average, a single photograph sells for $300 to $400 for a one-time, nonexclusive usage. Recently I supplied photographs to a children's book for a flat fee of $100 per photograph, with the stipulation that a minimum of twenty photographs would be used. More and more, I have been selling on a

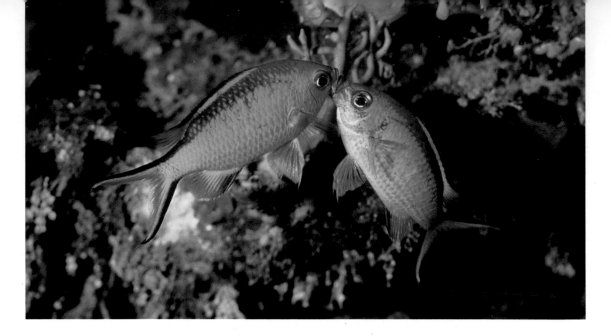

Blue chromis fighting for territory or a mate, Roatan, Honduras. *I have thousands of shots of these and similar fish in my files. This photograph has been chosen over the other ones again and again, for stock agency catalogs, calendars, and other usages. The difference is behavior. A photograph of any subject that shows behavior or a mood will sell far better than a straight documentary photograph of that subject.*

package basis, where a client purchases an entire article or set of photographs for a reasonable fee. Each submission in such a case should bring in at least $100 for each hour you spend filling the request.

Then there are the large, famous magazines. One large national magazine is hotly pursued by photographers. This magazine is one of the most famous outlets for natural history photography in the world, and it has a circulation of more than 20 million. I had a couple of small photographs published in this magazine several years ago, back in the beginning of my career. This magazine has a standard policy: to offer photographers extremely low rates at the start of a negotiation. If the photographer is a beginner (and this magazine does use beginners' work frequently), then more often than not, he will jump at the opportunity to see his work published in this prestigious publication. I am embarrassed to admit that I fell for this tactic myself. I received a letter from this

publisher stating something like "Congratulations on being published in *Prestigious Magazine*. You are one of the select few to be chosen to grace our pages, and it is a huge honor. You should actually pay us for the privilege of being included in our pages, but being a large, generous benefactor and sponsor of photography, we will pay you $100 per image." I readily accepted their terms. Over the years, however, I have come to realize that this magazine will pay almost anything once they have decided that they want to use your photograph. The trick is in getting them to select and want your photograph. Because this client does not use my work a great deal, and because they are one of the more difficult clients to work with, I charge them two or three times more than I charge my other clients. I've never had a problem, and I'll probably charge them even more the next time they call.

Of course, I value repeat business a great deal. If a client uses me regularly, I'll often

adjust prices to reflect a volume discount and generally accede to any requests they might have in terms of budget.

The Value of Communication

I have spent the last ten years building up a business based on my stock library of wildlife and travel subjects. I've developed a number of steady clients, and I have come to know my worth and the worth of my photographs. I find that I consistently obtain higher prices for my photographs than my stock agencies get for the same usages, even from the same clients. I know which books and tables to consult when a client calls, and I have a network of friends and colleagues that I can call if I have a question.

It was a surprise, then, to find that I grossly underpriced myself for a recent commercial shoot. A video producer called to ask my rate for photographing models using exercise products in a pool. The client was a large manufacturer of swim gear, and commercial shooting was something I had long desired to do but had little experience in. Ironically, I had just spent over $12,000 to design and print a flyer advertising my services to these types of clients, but the mailer hadn't come out yet. So I was quite eager to get this job. It was a rush job—the client needed these catalog shots right away, as the president of the firm had just vetoed photographs that had been taken for the catalog several months ago.

Because the parties involved were in such a rush, the shoot was set up within a few days. I didn't have time to properly research the marketplace, and instead I relied on my old notions of assignment shooting, as well as my experience shooting editorial features. Here is where I ran into problems. As an editorial photographer moving into a new market, I had no idea of the general operating practices in the advertising and commercial photography arena. In short, because of my ignorance, I underpriced myself for the shoot. I later found out through conversations with other photographers and the folks at the American Society of Media Photographers (ASMP) what the actual practices are these days.

The first thing I learned is that day rates are no longer used. Instead, a commercial shooter will charge a "creative fee," which takes into account the difficulty of the job as well as the usage of the photographs created. As Emily Vickers, former education director of ASMP puts it: "It's the usage, stupid." Put this way, pricing for a commercial shoot made perfect sense to me. If the client wanted to use five photographs produced that day for a catalog, a fee of $2500 for the job would be reasonable. The client would be getting a decent deal—$500 per photograph for usage in a catalog for one year—and I would be charging for usage. If the client wanted to use more photographs from the shoot for different purposes, then I would charge a reasonable fee for the additional usages. I could use the same tables and guides that I use for my stock photography business to price my commercial shooting. Many advertising photographers now charge a percentage of the total media buy for the ads (anywhere between 1 and 10 percent). When a double-page ad in *Newsweek* costs about $250,000, 2 percent to the photographer is $5000—a minuscule amount of the total that the advertiser is paying to create and deliver the message, especially when you consider that the photography is likely to be 70 to 90 percent of the message. Art directors and ad agencies have been charging this way for years. Their fees are partially based on a percentage of the client's total media buy for the campaign.

Photographers are in a tough business. Not only are we isolated, we are also competing against each other. Many of us operate in a vacuum, with little personal contact with each other or even our clients. As a

Swimmer, Moraga, California. *I produced this shot during one of my first commercial assignments. I found later that I had grossly underpriced my services for this shoot.*

Photo Asia cover. Reproduced with permission of *Photo Asia* magazine, Singapore.

wildlife photographer, when I am not out shooting, I am in the office putting together stories, writing, and handling the myriad other tasks necessary to keep the business going. I conduct most of my business over the phone. I have little time or desire to make the monthly meetings that my stock agencies hold, to meet with colleagues to discuss business, or even to socialize at local professional society meetings. I am fortunate to live near San Francisco, which has an ASMP chapter. Photographers who

live in remote areas may have even less contact with their peers than I do.

This lack of contact among photographers creates problems. Another photographer related a story to me about some top-notch magazine photographers who, "having operated exclusively in the editorial market for their entire careers, were approached in the mid-1980s by advertising agencies to produce photos for cigarette campaigns. Having no knowledge of the going rates for advertising photography, and unwilling or unable to approach estab-

lished pros in that market to get advice, these photographers—talented professionals—seriously underpriced themselves, with the net result of losing out on the lucrative rewards they deserved, and concomitantly doing irreparable damage to the pricing structure advertising photographers had spent years establishing with their clients. The editorial shooters didn't do this out of malice, they did it out of ignorance. Open communication among photographers about the value of their marketplace is the only solution to this problem."

Photographers need to discuss issues among themselves, figure out fair prices, and assert themselves in negotiations. The only way you can get a sense for the market is by talking to your peers. One of the best ways to get connected with your peers is through an organization like ASMP. Photographers would do themselves and the business a favor by discussing their business practices and fees openly and candidly with each other. I'm always surprised to hear that a photographer is secretive about his fees, as sharing information on fees is the only way photographers can keep their rates up. The more successful and professional shooters usually have no problem sharing their price guidelines with newcomers. They understand that communication and education are essential to the business of photography. Please note that I am not advocating price fixing. I am only suggesting that photographers communicate with each other to maintain fair prices and practices in the industry.

My membership in ASMP has helped me get through some of the most difficult negotiations in my career. I've been pleasantly surprised by the personal attention that the busiest people in ASMP have been able to give me. I've been able to contact the president, the executive director, the education director, and others directly for answers to my questions. Several cases this past year have made me value my membership in this organization even more.

In one case, a textbook publisher called me up to ask for caption information for some photographs of mine that they were using. Surprising to me was that this publisher hadn't received the photographs from my agencies or myself. On further investigation, I discovered that the publisher of one of my books on marine life had sold the rights to a reprinting of the book to another publisher, for use in schools. I ran into corporate stonewalling when trying to figure out who was responsible for the sales of rights and what my cut should be. The problem was compounded because I had signed the contract for the book with a book packager, not the publisher. My contract with the packager did not allow them to sell any other rights (called subsidiary rights) to any other publisher. Unfortunately, the packager's contract with the publisher was different. I brought the situation to the attention of ASMP, and the folks there helped me draft a letter and get the issue resolved. Ultimately the packager paid me for its share of subsidiary rights.

The advice given by ASMP's national office has been instrumental in helping me determine the fairness of contracts with electronic publishers, in approaching clients for nonpayment, and in answering questions regarding copyrights. There are other organizations dedicated to photographers, as well. A new organization for nature photographers, the North American Nature Photography Association (NANPA), aims to fill a sore need for communication among photographers practicing this specialty. The Professional Photographers of America (PP of A) is geared toward wedding photographers, and other professional groups are oriented to photojournalists (NPPA) and other specialties. As a photographer, joining one of these professional organizations is a strong first step in becoming a professional.

Better Business Practices

Seeing the Customer's Point of View
So, you want to sell your pictures. You've spent many years building up a collection of good images, and you've read a number of books on marketing your photographs. If you have done your homework, you've picked up copies of ASMP's books on stock photography and business practices. You've contacted magazine publishers, galleries, and other clients, and you've sent them all your best duplicate or original photographs along with ASMP-recommended delivery memos. In your delivery memo, you've specified that photographs are to be returned in two weeks, or holding fees will be charged at the rate of $5 per photograph per week. Like many photographers who are just starting to sell their work, you follow the guidelines and recommendations in this and other books religiously. When the two weeks roll by, you write a letter or call the publisher, asking for your photographs back. The letter isn't answered and your call is not returned. After another week, you write a heated letter describing your legal rights, and demanding your photographs back, along with the holding fees. You eventually get your photographs back, but you've almost certainly lost a client.

I'm here to tell you that the real world is very different from the world described in the pages of *How to Make Millions with Your*

Photography. The basic guidelines and recommendations in these books are good general rules, but a rigid adherence to rules and holding fees is not good business. As with many situations in life, seeing the other person's point of view will help avoid many problems and make success much easier. Seeing the publisher's point of view is essential in this strange business of nature photography. Unfortunately, most books on selling photography don't make this point strongly enough, if at all, and it is probably the most important lesson of all to learn.

The photographers who are making a living selling their photographs have many years of experience behind them in marketing, proposing, and organizing their work. A successful nature photographer has to learn a variety of tasks and has to be good enough, and pleasant enough, to encourage potential clients to return repeatedly. One photographer has mentioned that it is only the recent graduates, the young guys, that bombard a client with delivery memos, contracts, and ten-page warnings about misuses of photographs. I have made all the typical mistakes that beginning photographers make. If you can learn from my mistakes, then read on.

When I first started selling my work, I was one of those recent graduates, starry-eyed and convinced that my photographs were

the best in the world. It would take just a few visits to New York magazine publishers for me to hit it big. I was also convinced that my photographs possessed an artistry and vision heretofore unknown in the photographic community. My few successes served only to perpetuate my self-image. A few galleries accepted my work on a commission basis, and I even won a few contests. Gradually, however, I realized that my work was not really earth-shattering, my reputation was nonexistent, and my attitude and business practices were driving my clients away, rather than attracting them. After a few bad experiences, I had to rethink my business philosophy. I came to the same conclusion that most successful retail businesses make: The customer is always right. In this case, the customer can range from the individual buying a print to the giant publishing house purchasing an article. The customer is always right. Once you can understand the customer's point of view, then you will be much better equipped to serve his needs and guarantee his satisfaction with your service and product.

ASMP's Guidelines

The American Society of Media Photographers (ASMP) is an organization devoted to protecting photographers' rights, educating photographers, and improving the business of photography. It is a wonderful organization that produces educational and informative books and "white papers" about the business of photography. For the photographer starting out, becoming a member of this organization and studying its books are invaluable. It is probably the best photographers' advocate in the world. I highly recommend joining this worthy organization, but I have also heard one editor (who was also a working studio photographer) refer to it as "a bunch of left-wing militants." ASMP takes the photographer's point of view. The society is made up of photogra-

phers, and it is concerned with improving business conditions for photographers. Some of its guidelines are one-sided.

As someone who makes his living from stock, I have discovered, to my disappointment and dismay, that both clients and stock agents are easily scared off by the rigid contracts and delivery memos recommended by ASMP and other photographers' advocates. In one case, I had made proposals to a paper-products company and met with the publisher, at which point he agreed to publish two calendars featuring my work. I then sent him a letter detailing our agreement and contingencies. In response, this publisher shot off a letter to me, saying, "Don't contract me to death, Norbert. I am not your enemy and do not like to work with photographers who think I am." Fortunately, the publisher went ahead with the project, but it took a few phone calls to reestablish a working relationship, and the projects were given to a stock agent the next year.

In a more recent case, I made a verbal agreement with a small Caribbean airline public relations office to exchange photographs for free airfare. I sent the photographs with a standard ASMP-recommended delivery memo and a short letter outlining our agreement. The airline promptly returned my photographs and canceled our agreement, stating that they could not possibly comply with the terms of my contract (the delivery memo). Even after a few phone conversations and letters apologizing for the confusion, I lost the deal anyway. The airline decided that they did not want to deal with anyone as picky as I seemed to be.

In the most bothersome case so far, I met with the director of a stock agency in Los Angeles that has a good reputation and sends out informative, educational material to any photographer who inquires about joining the agency. This material includes general information about the stock busi-

ness and includes a list of questions to ask about any agency. The director is a well-known and highly regarded photographer himself, and the agency touts itself as a "photographer's agency." The agency agreed to take me on and faxed me a contract that I would sign before its annual photographers' seminar, coming up in two days. The contract was fourteen pages long, and I took the time to read it carefully and note any deviations from the ASMP recommendations. Since time was an issue here, I faxed my notes regarding the changes and questions about the contract back to the agency. The notes were four pages long as compared to the fourteen-page contract.

Guess what? The director gave me a call, saying that he had built this agency up from a handshake, and he didn't want to deal with anyone who was as nitpicky as I was. I was stunned, but in the years since this collapsed deal and tremendous waste of time and energy, I have spoken with other photographers and people outside the business, and I would like to offer a few counterpoints to the positions usually advocated by ASMP.

ASMP puts out a wonderful set of delivery memos and other forms to facilitate a photographer's business dealings. I use these forms routinely, but in the early part of my career, following their guidelines got me in trouble with clients or agents who were concerned about legalese, litigation, and getting the job done. This usually happened with clients who were not familiar with photographers' issues and standard business practices. I also learned the hard way that I needed to run my business differently from textbook recommendations. For instance, only allowing a client to hold your photographs for two weeks (the industry standard) will guarantee that you will never make a sale. Clients usually need to hold your photographs for much longer periods of time to get their job done. Photographers have a very tenuous connection with their

clients, and in most cases, it is better not to attempt to dictate to the client. I've observed two types of business practices among photographers. In one, the photographer very carefully draws out every detail, holds to standard industry form, and relentlessly pursues every legal avenue, holding fee, and lost transparency. In the other, the photographer sends a short invoice outlining the price agreed upon, sends dupes if there is any question about the client's integrity, and cultivates relationships over contracts. I'm sure that either approach has its problems as well as its good points, but I think the more easygoing approach will result in more business in the long run.

Situations and Solutions: Common Problems in Marketing Your Photography

Experience and knowledge are the keys to business. Anticipating situations and the possible solutions to those situations is the key to success in business. I give a few examples below of common problems and situations that nature photographers commonly find themselves in.

I recently participated in a seminar devoted to the business aspects of photography. In this seminar (the highly recommended and successful ASMP's Strictly Business Seminar), small groups of photographers take on roles and try to figure out the best way to solve a business situation. As a "role-play facilitator," it was my job to take on the role of an art director who wanted to reuse a photographer's portraits at no charge. I learned a great deal from this interplay about photographers' need to understand and plan for business negotiations before entering the situation. Here are a few situations that I have come across over the years, and I offer them here, along with my solutions.

For example, you have a great, expensive book of your photographs. Bookstores sell

it for a hefty price; it's been acclaimed by all who see it as a great job in terms of the photography, writing, and printing; and you have a few copies for yourself. An art director calls. They are in a rush to find a photographer for a promotional blitz for a new product, and they need to see your portfolio right away. Seem like a perfect time to send your book? Surprise—it's not.

Here's another situation. A film director calls you up, and as usual, he is also in a big hurry. He needs to see your work right away, and he wants to hire you to shoot a commercial—a plum assignment. Again, it would seem like a great time to send your book and prove to him that you are a master photographer. Is it?

Sending anything of yours that is valuable and that can be used for a purpose other than a portfolio is asking for trouble. In the cases above, both directors promised verbally to return the book promptly, to use it simply to evaluate my worthiness for a job. Incidentally, the book consists of the best of my underwater photographs, the two jobs were for underwater photography, and the book costs me a bundle. Both directors were in a rush to receive materials, and both directors were offering plum assignments that I was eager to take on. The problem arose when the art directors received the book. It turns out that they weren't in such a rush after all, they weren't the ones making the decisions, and their bosses decided to use stock photography rather than hire a photographer. After receiving the book, the art directors were reluctant and late to return my phone calls, and they conveniently forgot the conversations in which they promised to return my book. Most likely the books found their way into their collections, or were given as gifts to friends. When I asked for the return of the book, I was ignored; and when I wrote and demanded the return of the book, I was branded a "problem photographer!"

The moral: don't ever send anything of value to a client, unless you know them. Be extremely suspicious of high-flying, pie-in-the-sky, mega-deal types, who are always in a rush. Warning bells should go off immediately if one of these people asks for your portfolio to be sent next day, and if they expect YOU to pick up the cost of that next-day shipment. If they don't offer to give your their own Federal Express number to bill the shipment to, then be careful. This person will probably forget your phone conversation—he will not remember his promise to return your book, and he will say that he never authorized payment of your shipment via next-day air.

If your book is not returned, then you are stuck with harassing the client for its return, or gritting your teeth and taking the loss. By sending a portfolio, the art director has no real excuse. He can't give your portfolio away as a gift, and he won't want to put your portfolio into his collection. In addition, the portfolio is a time-honored method of showing your work for an assignment. In contrast, a coffee-table book of your photographs is not. An art director who sees a book may exclaim his delight at the printing, the design, the writing, and the superb photography, but he will then ask to see your portfolio!

I haven't figured out an elegant solution to this problem yet. When someone asks to see my portfolio these days, I send them just that. If one of my books seems like an ideal vehicle for a situation, then I ask the client to sign a short letter stating that he understands that the book is on loan, and that he will return it promptly. Unfortunately, I've found that clients rarely pay attention to such letters. It would seem like an easy thing for them to simply fax a letter back, but perhaps it gives the impression that you are nitpicky, cheap, or a pain to deal with. So the books and proposals sit by the door, waiting for the client. And the

client waits for the books, which never show up. You just lost a deal.

As a photographer, you need to project an image of professionalism. Much of professionalism is being prepared for situations that will inevitably arise while marketing your work. Experience and a sound approach to business are the key. The best way for a beginning photographer to gain experience quickly is to join an organization such as the American Society of Media Photographers (ASMP). Photographers' organizations such as these will provide manuals and guidelines that will detail ongoing practices in our profession.

Patience Is a Virtue

I am not a good salesman, but I'm learning fast. And as every successful salesman will tell you, the customer always comes first, and the customer is always right. I am in the business of selling my photographs to whomever wants to buy them. My clients range from art directors at advertising agencies, collectors of prints, and good friends. I have learned to let my customers keep my photographs as long as they need to. When I first started out, I held rigidly to the rules espoused by many photographer's organizations: two weeks holding period allowed, and then phone calls and letters every week until the photographs were back. If three weeks passed, I would send an invoice for holding fees. I kept up this practice until I realized that I was losing my magazine clients. One very prestigious (but low-paying) magazine never returned my calls, and after publishing me in one of their very first issues, never worked with me again, no matter how good my work was. Another magazine opened my eyes. They had held my originals for a good two months, after promising to return the originals in two weeks. They also lost a couple of my duplicate transparencies, so I do not consider them a good client, but the fact remains that what they said to me had the ring of truth. Take the customer's point of view. Publishing a magazine is a hectic business. Every day is a new deadline. The last thing a publisher or editor needs is a photographer banging on his door, barraging him with phone calls, to get a few slides back. Here's what the editor of this magazine wrote to me: "I don't know what publications you've conducted business with in the past, but I can speculate it wasn't on a repeat basis. You should know from experience a realistic time-frame needed to produce a magazine. . . . We appreciate the opportunity to have done business with you; if nothing else, it was revealing."

Photographers, like it or not, are a dime a dozen. If an editor is bothered by a photographer demanding his work back, he will more than likely not call upon that photographer the next time. As I sit here now, I just received a huge shipment of slides back. They were first sent in June of 1994! Another client of mine, one of my favorite clients, has kept some of my most valuable slides of sharks and sea otters for over a year! Yet, I don't feel that they are taking advantage of me. Many good things have come out of my relationship with them, and I understand that their projects necessarily take a great deal of time. I've solved the problem of having valuable images out of my files by setting up a duplicating machine in my office. I simply dupe out everything before sending it out. I let my clients know that they are looking at dupes, so they don't pass over my photos for lack of sharpness. I ask them beforehand exactly what they are using the photos for. If it seems like it will take a while, I send them dupes after asking. If they are good clients, and I know that they will handle my originals carefully and promptly, I'll send them originals.

Publishers and editors are people just like you and me. They prefer dealing with

photographers who are easy to get along with, who come up with the right stuff, and who are both professional and calm in business dealings. Take their point of view, cultivate the relationships, and your stock photography business will grow like a tree spreading out a network of roots. Over time, the relationships that you develop with your clients will be the most important indicators of your success in photography.

Tricks of the Trade

I present here several professional, cheap, and easy tips to make your nature photography easier. These are tricks of the trade that you will find invaluable when working in the field.

Use ice chests to store and carry your cameras. They weigh and cost very little compared to conventional camera cases, and they are much less susceptible to theft. I usually carry a selection of lenses, film, and camera bodies onto planes with me rather than checking them in, and this small selection will get the job done even if my other checked baggage is lost. Everything fits into an Igloo Playmate cooler, which I lined with hard foam filling with cutouts for various lenses. The cooler inevitably draws hard glances and comments from flight attendants, asking if I have any beer in there, or frozen fish. It is just small enough to squeeze into an overhead bin on just about every plane I have been on. Since most people think of coolers as food storage places, the average thief is less likely to steal a cooler than a special shiny aluminum case that screams "Cameras inside!" The added benefit of the Playmate cooler is its simple locking switch, which allows the triangular cover to latch over the cooler, yet opens quickly and easily. The triangular cover protects the camera gear from rain and splashes. The interior foam that I cut

out myself protects the gear from the bumps and shocks of traveling in a car or boat. So all the gear is protected from water splash and bumps, yet is quickly accessible.

I use the larger coolers, in the 60- to 100-quart sizes, for checked baggage. I store my tripods, dive gear, underwater housings, some camera gear, and clothes in these. The large Coleman coolers, rather than the Igloo coolers, are better for this. Coleman coolers have better handles, are stiffer, and seem to have more interior space than the Igloos, which have thicker walls. One advantage of coolers for diving gear and underwater cameras is that you can just fill them up with fresh water for rinsing, then drain from the bottom after your trip.

I usually wear some sort of windbreaker, especially when shooting from a boat. A Gore-Tex jacket is waterproof and can be used to cover the camera quickly when a splash threatens to soak the camera. Recently I used it to save my lens from oily whale breath when a gray whale blew out close to a boat that I was on. I also use the windbreaker to cover my long lenses on tripods when photographing in rain or heavy fog. The windbreaker fits into a small nylon bag that packs easily when not in use.

Tripods are deceptively complex pieces of equipment. Simply mounting a camera on a tripod does not ensure a sharp image. In

most cases, I put my hand on the top of the lens and camera to provide additional weight to prevent shake. In some cases, with very long lenses, I might use two tripods, one for the lens and one for the camera. Other photographers use bags of sand or rice draped over the long lens that is directly mounted to the camera. The additional weight keeps wind from disturbing the camera-tripod combination. With the older mechanical cameras, I have found in many cases that cable releases actually vibrate the camera more than if I had released the shutter by hand. The newer electronic cameras, with their electronic cable releases, are much better. Even better are the Canon EOS cameras, which feature mirror lockups coupled with infrared remote releases, thus enabling tripping the shutters of the cameras with no physical couplings at all. In many cases, simply squeezing off the shutter by hand while pressing down on it is better than using a cable release, electronic or otherwise.

I carry a small nylon bag with a zipper everywhere. When I arrive at a location, I fill this bag with rice or beans and use it as a window mount. Gallon-sized Ziploc plastic freezer bags are essential. I use these for carrying just about anything, but especially for carrying film. Each bag holds about sixty rolls of film. On a typical three-week-long trip I will go through anywhere from sixty to one hundred rolls of film. On each trip I also carry several small Tupperware or Rubbermaid containers, which contain the small screws, Allen wrenches, batteries, and other accessories that make life so much easier.

Batteries have been a continual problem, since underwater photography takes so much in the way of batteries, and I hope that I have finally figured out a solution. I use rechargeable nicad batteries, and I especially like the high-capacity nicad batteries from Radio Shack, which come only in the C and D sizes. Nicad batteries are charged by

Photographer Charles Lindsay with Igloo Playmate cooler–camera bag.

forcing a current through them; the output voltage of the charger is not usually an issue as long as it is higher than the battery set's voltage. With my nicad batteries and a special fast charger, I have solved my battery problems with this charger and a 220V-to-110V transformer for use in foreign countries. I particularly recommend the Franzus converters from hardware stores. These voltage converters come with a complete

Sunlight shafts in temple, Egypt.

set of adapters to use in various countries. Follow the manufacturer's recommendations for the batteries, which often specify maximum current input.

Traveling internationally has its own rules and tricks. Make sure you know all the conditions regarding excess baggage before you go. For instance, I arranged to fly on to the Red Sea via Egypt Air after a convention in London. Egypt Air is the best way to fly to the Red Sea from the United States, as it has two nonstop flights from New York and Los Angeles each week direct to Cairo. Flying this way, from the United States, passengers are allowed the standard two bags of 70 pounds each for checked baggage, and the fare is only slightly higher than the shorter flight from London. I discovered to my surprise, however, that the allowance for checked baggage is much lower when flying from London. This is because the rules for airlines that apply in the United States don't apply overseas. I was initially charged $600 for my bags, and after much handwringing and begging, only managed to get the excess baggage charge down to £180, or about $300. In cash. One way. For travel for a story that was sponsored by Egypt Air. All this because I assumed that it would be cheaper and easier to fly to Cairo from London. The other rule for international travel is that it is often cheaper and easier to travel with a partner than alone. On this last flight, I could have flown an assistant with me for less than the cost of the excess baggage.

PART • ELEVEN

Ethics and Etiquette

Ethics is a hot topic in nature photography now, and it is a topic that all photographers should start thinking about. A lack of thinking on this topic can create enemies, bad will, and problems between photographers themselves and between the institutions that oversee the lands and subjects that photographers would like to photograph. More than one photographer has lost clients by not thinking through the problems involved with ethics.

Business Ethics

Most professions have associations and a code of ethics that binds them. Photographers are unusual in the professional world since anyone, no matter how naive or unknowledgeable, can call himself a professional photographer. As a photographer, it's easy to operate in isolation, without realizing that your lack of knowledge regarding standard business procedures or the expectations of editors can lead to unethical behavior. For example, I routinely send out multiple or simultaneous submissions of my photography and writing to different magazines. This practice usually does not cause problems; my editors know me and my style, and they have approved receiving photographs or stories that have been published or submitted to other publications. Occasionally, however, this practice has

landed me in hot water. One editor wrote me back when he discovered that a rival publication had decided to purchase rights to a story that I had also sent him: "You are a talented and hard-working photographer, but your journalistic methods need refining. Editors have no problem looking at simultaneous submissions or previously published material *as long as you are up front about it.* Failure to do this can make the editor feel misled." In this case, I had made a procedural mistake that came across to the editor as a lack of ethics. In the interests of efficiency, I had neglected to ask the editor about his policy before sending him material, and I had neglected to put notices across the manuscripts regarding their submission or publication status.

One magazine has a list of guidelines for photographers and authors stating that they will not accept articles that have been sent to any other magazine. They will not even allow their writers to publish similar stories in other magazines, and they will immediately drop any writer who violates this policy. This is a tough policy. If you don't read this magazine's guidelines and make the mistake of publishing your article elsewhere, you can forget writing for this magazine ever again. This sort of reasoning is prevalent at many publications. If you anger an editor at any magazine with your business practices,

123

Bottlenose dolphin chasing a school of bigeye scad, Roatan, Honduras. *This is a captive dolphin. It is kept along with several other dolphins in a huge, acres-wide enclosure in a bay at a resort–marine institute operation in the Caribbean. I am always honest about the fact that this photograph was taken in controlled conditions. Most clients ask about the captivity, and then they go ahead and use the photograph. In fact, I cannot think of one instance where I have lost a sale of this image by being honest.*

you will have lost a client, because your ignorance about procedures will mistakenly be perceived as a lack of ethics. For instance, I regularly contribute to several diving magazines here in the United States. These dive magazines, although competing with each other, don't often take the stance that a photographer who contributes to one magazine is not allowed to contribute to another. I was recently surprised by a situation in Germany, however, where I was notified that should I contribute to one magazine, another magazine would no longer accept my work for publication. If you aren't familiar with policies at the magazines, simply contributing a photograph to one magazine could anger an editor at a competing magazine, and you may lose a valuable client.

Problems such as competition between publications are more correctly termed political rather than ethical. I'd make the argument that many publications are not ethical, whereas the same publications may argue that their practices are legal and prac-

Sooty tern attacking intruder in nesting territory, French Frigate Shoals, Hawaii. *I was intruding on these terns' territory in order to create a story on the life of these islands. I did so only after consulting with the scientists studying these birds and proceeding under their guidance. Nevertheless, the fact is that all photographers will disturb their subjects to some degree. All the photographers in the world, however, do far less damage than one golf course or condominium development. I am always appalled at the way photographers are singled out by the government and other bureaucracies as sources of income and targets for harassment. For instance, the U.S. Bureau of Land Management started charging photographers up to $500 per day to photograph on public lands. Ironically, the BLM charges only $1 per year for mining companies to strip-mine these same lands! They withdrew this incredibly unfair decision only after intense efforts by ASMP, NANPA, and other photographers' organizations. In the words of Richard Weisgrau, executive director of ASMP, "Please be fully aware that the ASMP shares the concerns that nature photographers' rights may well be encroached in a much faster and alarming rate in years to come. Creative people are always easier targets to hit than the powerful corporate and business interests in the country when it comes to exacting the toll for use or access to government controlled lands."*

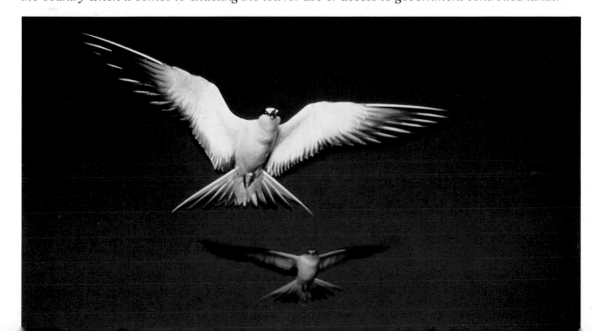

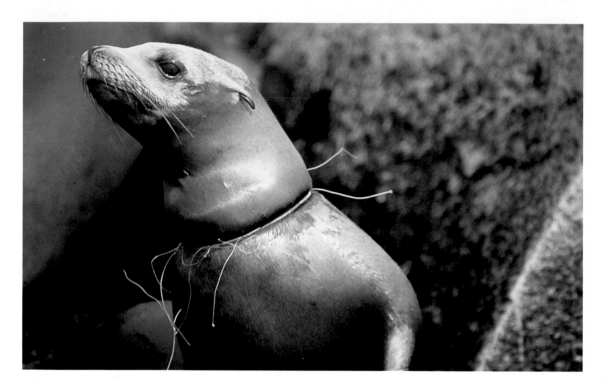

This sea lion caught in a gill net will slowly strangle, California. *Photographers have contributed more than nearly any other group to conservation and environmental regulations. Gill nets are now outlawed off the U.S. coasts. Unfortunately, the environmental and conservation movement has taken a hysterical turn. Photographers are now often accused of harassing marine mammals, even if they are approaching the animal with care and doing good with their photographs. I am continually appalled at people who have taken their love of nature to extremes, not realizing the damage they are doing with their false and misinformed accusations.*

tical. For instance, I recently was asked to write a short article for a magazine. The editor faxed me a contract stating that my article would be a work-for-hire, that all rights to my writing belonged to the publisher. Any photographer with a knowledge of standard business practices knows that signing a work-for-hire agreement, except under very special circumstances, is very much against his interests. In fact, I would label any publication that requires a contributor to work under a work-for-hire agreement as unethical, or at least grasping, uncaring, and selfish. I sent a fax to the editor turning down

the assignment because of the work-for-hire clause. It was enlightening to me when the editor sent me another contract, identical to the first one except for a clause replacing the work-for-hire condition. This magazine obviously knows what is in its best interests, and its policy is evidently geared toward taking advantage of photographers who lack professional knowledge regarding contracts.

The best solution to these sorts of problems is to join a photographers' organization, such as ASMP. A good organization of photographers need not be large; simply sharing ideas and experiences with a few

friends can help you come up with solutions to ethical and political situations.

Ethics in Nature Photography

I recently heard about a wildlife photographer who submitted a photograph of a captive wolf to an editor at a natural history magazine. The editor asked the photographer if the wolf was captive, and the photographer hemmed and hawed, then finally admitted that it was a captive animal. The editor told him to never submit to that magazine again. The editor felt, however, that if the photographer had been forthright about the conditions of the photograph immediately, there would have been no problem.

This situation brings up several points about ethics in nature photography. Anytime a discussion about the morality of photographing captive animals comes up, any wildlife photographer within hearing distance will have a different point of view, based on his particular circumstances. One photographer who argues vociferously against digital manipulation of photographs, which he says threatens the entire future of photography, has no problem selling his photographs of a trained grizzly bear standing up on its hind legs, in a completely unnatural and entirely learned posture. Some wildlife photographers who go to great lengths to capture animals' behavior in the wild will completely disrupt their subjects' environment, building blinds and towers to reach the nests, blinding the animals with flash, and attracting the attention of predators to their subjects. These photographers will vehemently argue against the person who photographs captive animals, citing morality and cruelty to animals. They ignore the fact that the captive animal may have been rescued and photographed at a shelter, or that they disturb their wild subjects more than does the photographer of captive animals. My feeling regarding the photography of captive animals and the general problem of ethics in the field is that if you're embarrassed to admit something, then it is probably wrong. Ethics boils down to telling the truth. If you take a photograph of a captive animal, don't submit that shot to a feature that shows only natural behaviors.

In the world of physics, there is a basic rule called the Heisenberg Uncertainty Principle. The Heisenberg Uncertainty Principle applies equally well to the observation of wildlife. Quite simply, the principle states that the very act of observing a particle or subject changes the behavior of that subject. If you are going to take photographs of animals in the wild, your very presence will change that animal's behavior. The best photographers know this, and they work to become so much a part of their subjects' environment that the animals accept their presence. Getting to know the environment and your subject is the most important way to photograph wildlife without disturbing it. Only by understanding your subject will you come to learn its personal space, that distance beyond which you will disturb your subject. It's the unknowledgeable photographers, those grinning tourists who stand next to wild lions in the Serengeti, the amateur photographer who walks into a field of nesting birds, scaring them all from their nests, that give the rest of us a bad name.

Ethics is about getting along with others, about letting photography take a backseat to courtesy and humility, about working within the system to accomplish your goals. The photographer who pushes other people aside to get the shot gives the rest of the profession a bad name. The image of the pushy, overbearing news photographer is unfortunately the image that many people have of nature photographers. Let's all think a little more about our goals, our knowledge, our subjects, and the people around us. Thinking before acting is the best policy in any situation, be it in the field or the office.

RESOURCES

Photography Equipment

The following are manufacturers of photography equipment mentioned in this book. This is not a complete list. Makers of photographic gear range from large companies to small garage operations, and the quality of gear varies just as widely.

B and H Photo
119 West 17th Street
New York, NY 10011
orders 800-221-5662
212-242-6115
fax 212-366-3733

I, like many professionals, buy most of my gear and film from this New York mail-order house. B and H is honest, knowledgeable, and trustworthy, unlike many other mail-order firms. It has a huge selection, much more than any local camera store, and its salespeople are knowledgeable. I lament their new voice-mail system, however, which takes up to five minutes before you get anywhere.

Bogen Photo Corp.
565 East Crescent Avenue
Ramsey, NJ 07446
201-818-9500

Distributes the Bowens Illumitran line of slide-duplicating machines.

Camera Tech
2308 Taraval
San Francisco, CA 94116
415-242-1700
fax 415-242-1719

Geoffrey Semorile of Camera Tech is a wealth of information about photographic gear. His shop carries a full line of parts for cameras and does custom work and repairs on any type of photographic equipment.

Canon USA Inc.
One Canon Plaza
Lake Success, NY 11042
516-488-6700

Charles Beseler Co.
1600 Lower Road
Linden, NJ 07036
908-862-7999
fax 908-862-2464

Manufactures the Beseler dual-mode slide duplicator.

Chicago Packaging/Mail Safe
4340 West 47th Street
Chicago, IL 60632
800-848-6552
fax 800-521-3489

Source of rigid cardboard mailers, used for shipping photos.

Compuserve Information Service

I use my membership in this worldwide computer service mainly for E-mail. The Photography Forums on this service are a good way to keep in touch with other photographers. If you are a CompuServe member, GO PHOTOGRAPHY. If you are not a member, a free trial subscription to CompuServe may be obtained by calling 800-487-0453 and asking for representative #159.

Icon Distribution/Clear File
1342 E. Vine Street, Suite 342
Kissimmee, FL 34744-3655
800-801-2128
407-944-3875
fax 407-944-0408

Icon Distribution is a distributor of Clear File slide pages, or vis pages. I prefer the Archival Classic (Format #21) pages, which are top-loading pages for twenty 35mm slides.

Fuji Photo Film USA
555 Taxter Road
Elmsford, NY 10523
914-789-8100

Ken Hansen
Ken Hansen Photographic
625 North Flagler Drive, Suite 504
West Palm Beach, FL 33401
407-832-4844
fax 407-832-3929

Ken Hansen is an expert in photographic gear, a great source of expert advice on used and new equipment and hard-to-find parts.

Helix Photo
310 South Racine
Chicago, IL 60607
800-33HELIX
fax 312-421-1586

The best source in the United States for underwater photography equipment and books dealing with any marine subject. A good source for any kind of photography equipment.

Ikelite
50 West 33rd Street
Box 88100
Indianapolis, IN 46208
317-923-4523
fax 317-924-7988

Ikelite makes the wonderful Lite Link cordless TTL slave for use with various flash units. This small device, which attaches to the hot shoe of any Nikon TTL flash unit such as the SB-26, allows TTL shooting without cords. Ikelite also makes a variety of products for the underwater photography market, many of which make wonderful items for backpacking and outdoor environments.

Kodak
343 State Street
Rochester, NY 14650
800-242-2424

Nikon, Inc.
1300 Walt Whitman Road
Melville, NY 11747
516-547-4200
fax 516-547-0309

Photographic Solutions, Inc.
7 Granston Way
Buzzards Bay, MA 02532
800-637-3212

Manufacturers of PEC-12 Cleaner, which I use for cleaning my transparencies.

The Stock Solution
307 West 200 South #3004
Salt Lake City, UT 84101
800-777-2076

Sells self-sealing mounts and caption labels for all formats of transparencies. The 3^1/2-by-7/16-inch labels are perfect for captioning 35mm slides and are far cheaper purchased in quantity here than through other distributors. A box of ten thousand pinfed computer labels sold for around $40 in 1996.

Recommended Reading

ASMP Stock Photography Handbook, 1st and
 2nd editions
American Society of Media Photographers
 (ASMP)
Washington Park, Suite #502
14 Washington Road
Princeton Junction, NJ 08550
609-799-8300
fax 609-799-2233

Absolute musts for any photographer's bookshelf. The first edition (1984, not in print) contains an invaluable pricing section that gives usage fees for photographs depending on the type of publication, the circulation or size of printing, and size on the page. Unfortunately, you will have to beg, borrow, or steal this edition from a veteran photographer. The second edition (1990) is more up-to-date, but instead of giving specific prices, it devotes a chapter to negotiating and pricing your photographs. Both editions are invaluable for determining the worth of your work and gaining an overview of the stock photography business.

Nature Photography Magazine
P.O. Box 2037
West Palm Beach, FL 33402

A magazine dedicated to natural history and nature photography.

Photo District News
49 East 21st Street
New York, NY 10160

This monthly magazine devoted to professional photography contains items of interest for all photographers. A regular column featuring stock agencies and photographers brings up issues of usage fees, negotiation, exclusivity, pricing guidelines, and other newsworthy items.

Negotiating Stock Photo Prices
110 Frederick Avenue, Suite E
Rockville, MD 20850
301-251-0720
fax 301-309-0941

This small book is the best guide to pricing today. Author Jim Pickerell explains how to arrive at the price for an existing photograph through negotiation and includes valuable tables. Buy a copy and keep it near your phone; refer to it the next time a buyer wants to know your fee for a photograph.

Guilfoyle Report
AG Editions
41 Union Square West #523
New York, NY 10014
800-727-9593, 212-929-0959
fax 212-924-4796

This newsletter is aimed at nature photographers and includes profiles of markets such as calendar and greeting card companies, as well as monthly listings of photographs needed by clients. AG Editions also publishes the *Green Book* and *Blue Book Directories*, which are catalogs containing photographers' descriptions of their stock and capabilities for the natural history and travel markets, respectively.

131

The Natural Image
P.O. Box 6240
Los Osos, CA 93412
805-528-7385

This is a great little newsletter, filled with practical tips and reviews on equipment and lenses that are of interest to nature photographers.

Photograph America Newsletter
1333 Monte Maria Avenue
Novato, CA 94947
415-898-3736
fax 415-898-3787

This intimate and valuable newsletter describes popular photographic locations around the United States in detail, including restaurants, lodging, and photographic tips.

Photographer's Market
Writer's Digest Books
1507 Dana Avenue
Cincinnati, OH 45207

This annual book contains listings of thousands of sources to sell your photographs.

Slide-Duplicating Laboratories

The Darkroom
9227 Reseda Boulevard
Northridge, CA 91324
800-442-3873 (DUPE), 818-885-1153

Faulkner Color Lab, Inc.
1200 Folsom
San Francisco, CA 94103
800-592-2800, 415-861-2800

Photo Craft
3550 Arapahoe Avenue
Boulder, CO 80303
800-441-3873 (DUPE), 303-442-6410

Photographers' Organizations

American Society of Media Photographers (ASMP)
Washington Park, Suite #502
14 Washington Road
Princeton Junction, NJ 08550
609-799-8300
fax 609-799-2233

If you are a professional photographer, you owe it to yourself and the profession of photography to join this fine organization. There is no excuse not to join if you are making a living as a professional, as ASMP is fighting battles on behalf of all photographers. If you are a student, a beginning, or an aspiring photographer, ASMP offers affiliate memberships just for newer photographers. I am continually surprised at the accessibility and the foresight of the national office.

Media Photographers Copyright Agency (MP©A)
Washington Park, Suite #502
14 Washington Road
Princeton Junction, NJ 08550
609-799-8300
fax 609-799-2233

MP©A is an ambitious effort to create a photographers' agency that can collect royalties on behalf of photographers. MP©A is a solution to the problems photographers have with impersonal, powerful, manipulative stock agencies. I highly recommend joining this agency.

North American Nature Photography Association (NANPA)
10200 West 44th Avenue #304
Wheat Ridge, CO 80033
800-777-1141, 303-422-8527
fax 303-422-8894

This new organization is dedicated to addressing the concerns and education of nature photographers.